CAMDEN GOODS STATION
THROUGH TIME

Peter Darley

AMBERLEY PUBLISHING

Front cover images:
Camden Town Station and Pickford's Shed, 1848, W. H. Prior (*NRM/SSPL*)
Camden Passenger Locomotive Shed, 1938 scene, 1958 (*G. Peter M. Green*)

The 'Great Wall of Camden' (*Fay Godwin*) symbolised the separation of the Goods Station from the public. The massive wall ran along the Hampstead Road from just north of the canal bridge to beyond the Roundhouse. It retained up to 15 feet (4.6 m) of fill, the level of the railway lands above street level. David Thompson described it as '... higher and blacker than the wall of Manchester's gaol ...' (*In Camden Town*).

The barrier was mental as much as physical, to which the dearth of text and images about the activities behind the wall bears witness.

The Great Wall is far less threatening for today's pedestrians on Chalk Farm Road, having been much diminished by development.

About this book

Camden Goods Station is intimately connected with the Regent's Canal, with the main line railway to Euston and with the North London Railway to the Docks. This book takes as its scope the local history of these over two centuries together with associated industry and commerce. It also looks at the remarkable regeneration witnessed since the goods station fell to the developer's hammer. While the area remains extraordinarily rich in historical features, it is not always easy to tease out the threads that link them, either in time or space. This book will have succeeded if it assists this process. Please note that public access and photography is restricted in many places for a variety of reasons and this book should not be seen as encouragement for urban exploration.

The author's revenue from the sale of this book goes to Camden Railway Heritage Trust.

First published 2013

Amberley Publishing
The Hill, Stroud
Gloucestershire, GL5 4EP

www.amberley-books.com

Copyright © Peter Darley , 2013
The right of Peter Darley
to be identified as the Author of this work
has been asserted in accordance with the
Copyrights, Designs and Patents Act 1988.

ISBN 978 1 4456 2204 0
EBOOK 978 1 4456 2220 0

British Library Cataloguing in Publication Data.
A catalogue record for this book is available from the British Library.

Typeset in 9.5pt on 12pt Celeste.
Typesetting by Amberley Publishing.
Printed in the UK.

1: Introduction

The area of focus of this book is shown on page 4. From being transported along the main line railway between Primrose Hill Tunnel and Euston, we deviate onto sidings at Camden Goods Station and branch onto the North London Railway (NLR). The journey is one through both time and space and explores a number of side tracks.

Before the advent of the railway, road and canal were the main transport modes. The Regent's Canal had been built between 1812 and 1820 to link the Grand Junction Canal's arm at Paddington Basin to the Thames at Limehouse while short-stage coaches, for which commuters paid up to three tolls, provided the only public conveyance to the City and West End from Hampstead in the 1830s.

The London & Birmingham Railway (L&BR) was the first railway authorised to extend into London as far as the New Road (now the Euston Road) for passenger services. The opening of passenger services from Euston in 1837 (**Chapter 2**) signalled the decline of longer distance commuting by road.

However, it was goods traffic that was the initial stimulus for construction of the L&BR. In response to this threat, the Regent's Canal Company insisted that railways take goods traffic no further into London than the edge of the Canal. The L&BR therefore planned a goods terminus at Camden Town adjacent to the Hampstead Road alongside the Regent's Canal. From what became Camden Goods Station (**Chapter 3**), rail freight destined for waterside locations, including the Docks, was transferred to the Canal, while other freight was discharged onto the road system. Camden Goods Station rapidly developed into an important interchange depot.

In 1846 the L&BR amalgamated with several companies to become the London & North Western Railway (LNWR), largest of the Victorian era companies and, briefly, the greatest joint stock company in the world. Passenger and goods services continued to grow through the nineteenth century, requiring major restructuring of the goods station and its separation from passenger services (**Chapter 4**).

The facilities for goods interchange and distribution associated with the Goods Station, attracted commercial and industrial enterprises ranging from the lower value coal, timber and stone, to the higher value piano assembly and wines and spirits (**Chapter 5**).

Horses were central to the operation of the Goods Station and to the collection and distribution of goods for more than 100 years. This has left the former Goods Station with the most complete industrial stables complex in the UK (**Chapter 6**).

The Railways Act which came into effect on 1 January 1923 and gave rise to the London Midland & Scottish Railway (LMS) from the LNWR, the Midland Railway, the Caledonian Railway and a number of smaller railways, once again created the largest joint stock company in the land, ushering in a new era that included the heyday of steam (**Chapter 7**), to be followed in the second half of the twentieth century by the nationalisation of the railway and the decline of steam.

Railway development has left an exceptional railway heritage with four Grade II* listed structures: the Roundhouse, Primrose Hill Tunnel east portals, the stationary winding engine vaults and the Horse Hospital as well as many Grade II features. A remarkable collection of vaults and other underground features represents every stage of goods station development from 1837 to the 1930s, associated with goods interchange, goods storage and stabling.

Since the end of steam in 1962, the area has undergone a remarkable regeneration (**Chapter 8**), tentative at first but gathering pace over the last thirty years to become one of London's premier tourist destinations. This presents new challenges for those that wish to preserve a sense of the past.

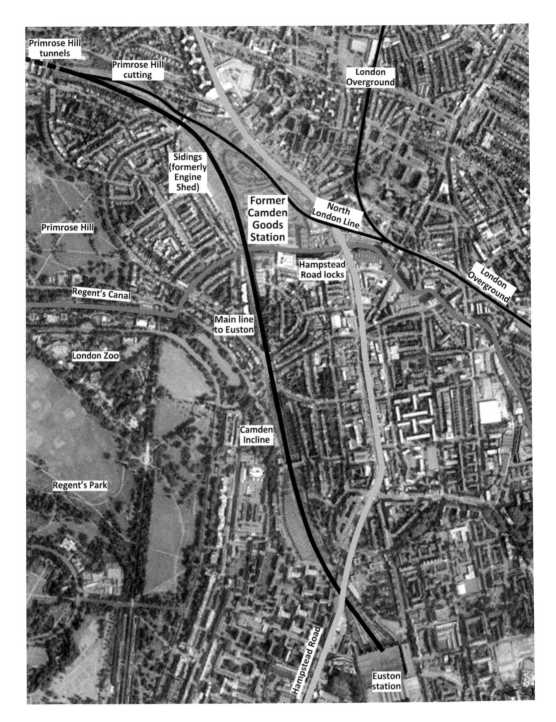

Location and associated features

This recent satellite image of the area shows the main line railway from Primrose Hill Tunnel east portals passing Camden Goods Station and descending from the Regent's Canal down Camden Incline to the terminus at Euston. The North London Line, which traverses the former goods depot, is now used mainly for freight with passengers using the London Overground branch. (*Map data: Google, Bluesky*)

4

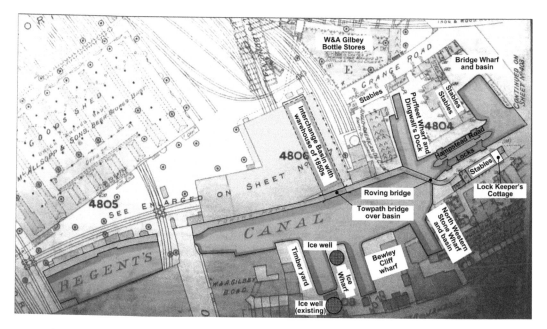

The Regent's Canal

The Regent's Canal reached the Hampstead Road in 1816 and traders formed docks on both sides of the canal as shown on the Goad Map of 1891 (*CLSAC*). The first lock constructed there was a two stage single lock with a highly innovative hydro-pneumatic mechanism patented by William Congreve, an inventor of repute. The system was abandoned shortly after in favour of a conventional double lock with a single lift of 6 feet 8 inches (2.0 m) dating from 1820, as may be seen today alongside the Lock Keeper's Cottage of 1816. The Roving Bridge and Interchange Building enhance this captivating scene.

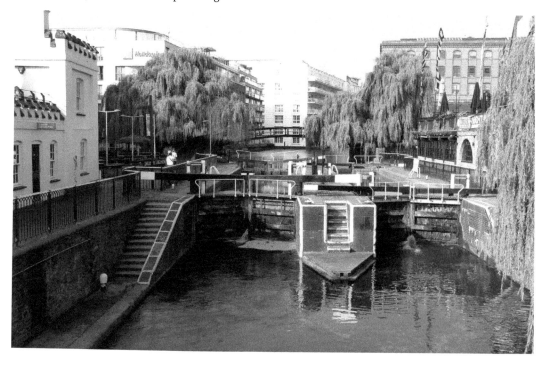

2: The London & Birmingham Railway

The London & Birmingham Railway (L&BR) was London's first main line and the largest civil engineering project yet attempted in the country. The first railway of any length, it changed the travel and commercial habits of the British people. The experience gained formed the basis for much of the development of civil engineering in Britain and established the construction technology of the railway age. It also precipitated the railway mania of the 1840s.

Robert Stephenson, son of George Stephenson, was appointed engineer-in-chief for the whole line in September 1833. He was not yet thirty. He lived from 1836 to 1842 at 5 Devonshire Place, on the west side of Haverstock Hill, at the corner of Belsize Grove.

The route of the line at the London end was dictated by the desire to reach the docks. Forced by high ground to approach London from the west rather than the northwest, it made its way around the edge of the built up area, heading slightly north of east and passed between the southern flank of Hampstead Heath and Primrose Hill. Gradients were kept low by means of nearly three miles of cutting and the 1,120 yard (1,024 m) Primrose Hill Tunnel. From there until Chalk Farm Lane Bridge, it entered a deep cutting before turning south towards the Euston passenger terminus. Goods trains, on the other hand, were diverted to Camden Goods Station, shown in red on the 1840 Davies map below.

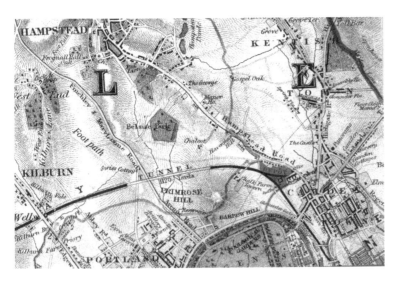

The first sod for the L&BR was cut at Chalk Farm on 1 June 1834. Blue London clay caused difficult ground conditions on the Primrose Hill contract, including the tunnel and deep approach cutting, which bankrupted the contractor. The work had to be taken over using direct labour.

The Euston extension, approved in 1835, diverged to the south at Camden Goods Station to pass over the Canal, pass under the street network and reach the terminus at ground level. Later railways in the Camden area were to avoid such a steep gradient either by going under the canal, as at Kings Cross, or by raising the rail terminus on arches, as at St Pancras.

Initially Stephenson proposed to run the Euston Extension on a viaduct, but influential landowners and wealthy residents in Park Village were concerned about the noise and smoke from locomotives toiling up the Incline and opposed any facilities at Euston to service and maintain locomotives. In response the L&BR Company decided to place the rails in a cutting and work trains up the Incline, at 1 in 85 the steepest section on the line, by an endless rope that ran around a driving wheel and other

large sheaves and pulleys. Motive power was provided by two condensing beam steam engines of 60 hp, working side by side on a common shaft, housed in a stationary engine house in vaults beneath the rail tracks. Communication between Euston and Camden was by pneumatic telegraph, a plunger at Euston activating an audible signal at the winding engine house.

The Regent's Canal had to be crossed at a height that allowed boats sufficient clearance; the ground at Camden Goods Station therefore had to be raised, while that at Hampstead Road and other crossings had to be lowered for rail tracks to pass under the roadways.

When the Euston to Boxmoor section opened in July 1837 locomotives at front and rear were used to work the trains up the Incline for the twelve weeks before the winding engines were commissioned. From October 1837 the train from Euston, limited by design of the rope system to twelve carriages, arrived at the bridge that carried the railway over the Regent's Canal. The 'messenger', which attached the first carriage to the endless rope, was cast off before reaching the winding engines below. Carriages were then allowed to run along the line until they met and were harnessed to the locomotive engine, by which they were pulled to Birmingham. From the stationary engine house to Chalk Farm Lane Bridge, the gradient reversed to a slight fall, engineered to check the speed of a train coming into London, and to give an impetus to one leaving London. 'Up' trains from Birmingham would stop at Camden for tickets to be collected and for the locomotives to be removed before descending to the terminus at Euston by gravity under the control of a 'Bankrider'.

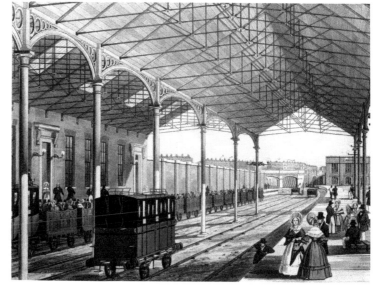

In 1837 there were three 'down' trains a day going north pulled by small and slow locomotives. First class passengers travelled in comfortable covered coaches but third class wagons were open, without windows, curtains or seat cushions. Both forms can be observed in T. T. Bury's painting of the arrival and departure platforms at Euston Station in October 1837, as can the absence of locomotives. Third class was stopped that month to be resumed three years later with third class trains and closed carriages. The through line from London to Birmingham opened for public service on 17 September 1838.

About five years later, with trains becoming longer, faster and more frequent, rope working had become an operational constraint. It was decided that locomotives should manage the Camden Incline with a second locomotive or 'banker' at the rear of the heavier trains. The stationary engines were therefore abandoned in July 1844.

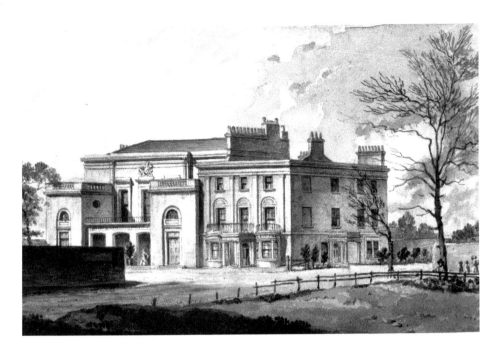

The design office

The engineering team was initially based in Kilburn. In May 1834 the office staff moved to the vacant Eyre Arms Tavern, named after a major landowner in the area *(Westminster City Archive)*. The main lounge was adapted as the drawing office and became a classical example of the organisation of engineering work, with an output averaging thirty drawings a week. Part of a drawing, a cross section of the retaining wall at the south end of Camden Incline, is shown below *(NR)*. The tavern was at 1 Finchley Road at the junction with Grove End Road. Its grounds were the scene of early balloon attempts, the last in 1839. It was demolished in 1928. Now the site of a block of flats, a plaque on the wall recalls its past.

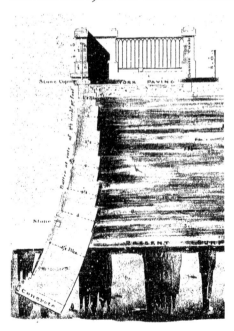

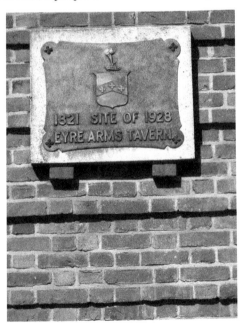

Stephenson and Brunel: the L&BR and GWR

Camden and Euston Stations were originally to serve both the L&BR and the Great Western Railway (GWR). The extension from Camden to Euston was therefore designed for two pairs of tracks. As a result of Brunel insisting on a 7 foot (2.1 m) gauge, among other disagreements between the companies, the western tracks were never used by the GWR. Despite their public rivalry, these two great engineers refused to make political capital from each other's mistakes. They developed a strong professional respect that warmed to support and friendship. Below Brunel (far right) and other eminent engineers discuss Stephenson's bold flotation of tubes for Britannia Bridge (*ICE*).

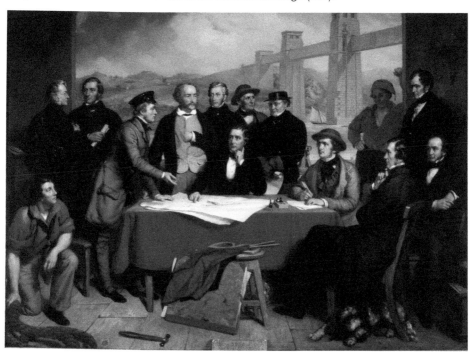

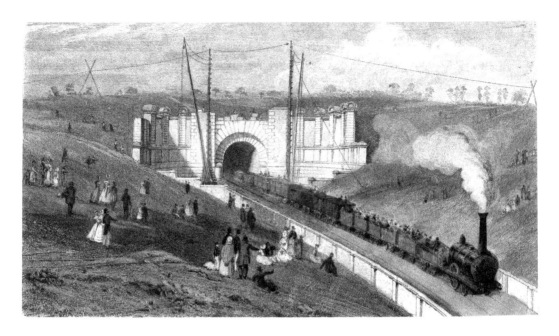

Primrose Hill Tunnel entrance

The L&BR Company planned to run its line across the emergent Eton College Estate. It bought off College obstruction by agreeing to put the line in tunnel, thereby using little land and ensuring the least interference with building values. Eton insisted that 'the mouth of the Tunnel at the eastern end shall be made good and finished with a substantial and ornamental facing of brickwork or masonry to the satisfaction of the Provost and College'. People were encouraged to stroll along the cutting to admire trains in operation (*NRM/SSPL*). The portal remains intact with opportunistic vegetation taking hold.

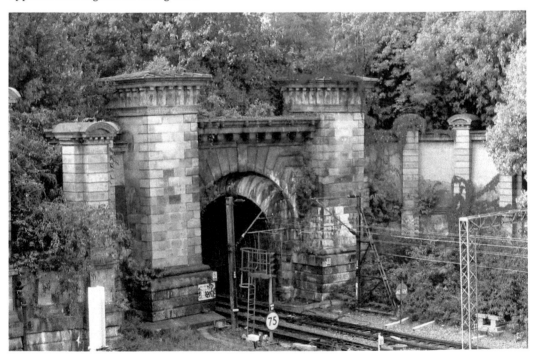

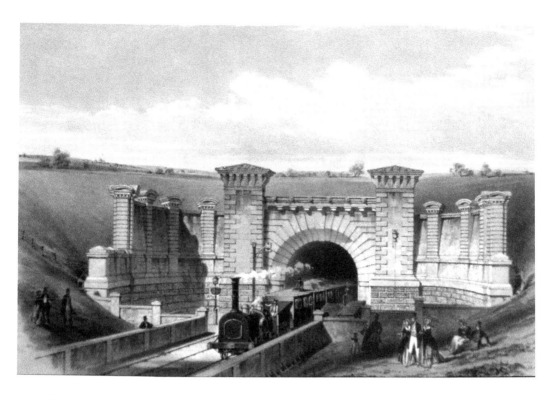

The original Primrose Hill Tunnel was London's first railway tunnel and considered a great feat of engineering in its time. Public anxiety about tunnels was not set at rest until a trial trip was made into Primrose Hill Tunnel carrying engineers and doctors to blow off steam for twenty minutes, an expedition with which all expressed themselves delighted. It was the first tunnel nationally to treat a portal architecturally, and is an elegant reminder of a former railway age. The round-arched tunnel mouth is crowned by a dentilated cornice decorated with six carved lion masks linking to massive stone flanking piers with hipped capitals. The whole conveys the sense of a grand entrance.

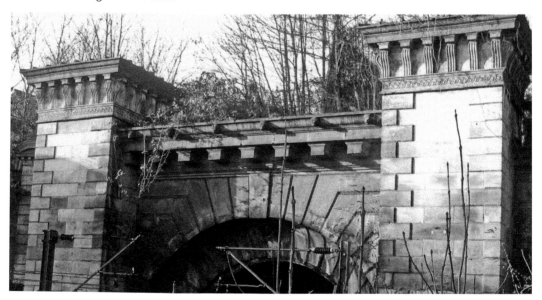

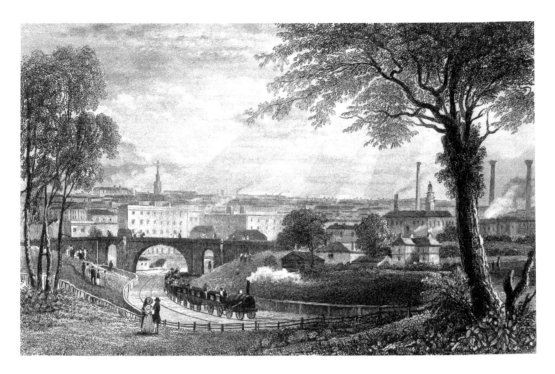

Bridge on Chalk Farm Lane

The first bridge on Chalk Farm Lane crossing the railway was a brick-built arch. The two chimneys of the stationary winding engines and the chimney of the coke ovens can be seen on the right (*CLSAC*). Initially passengers were unable to alight at Camden Station as the Hampstead Road was considered unsuitable, and a passenger station was created at Chalk Farm Bridge. The bridge was replaced in 1847 by a wrought iron box girder bridge to span three additional tracks (p.33). The present steel girder bridge dates from electrification of local lines in the early twentieth century.

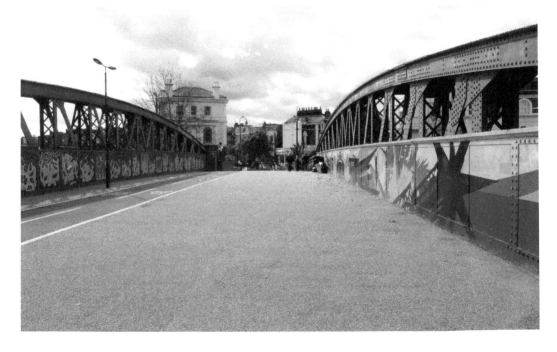

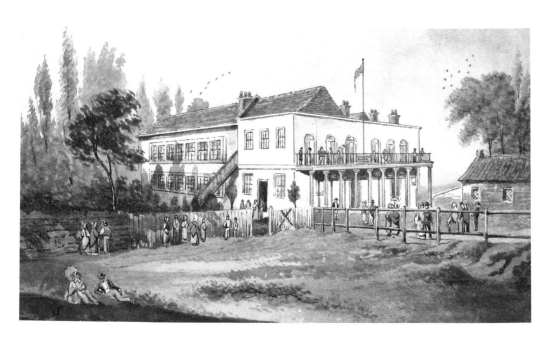

Chalk Farm Tavern

Primrose Hill had long been a favourite place for a day out and the old Chalk Farm Tavern on Chalk Farm Lane off the Hampstead Road catered for Londoners with pleasure gardens, bandstand, dance floor and varied entertainments (*CLSAC*). When the tunnel was being built, the Chalk Farm Tavern was usually the first resting place of navvies killed in the works. The Tavern was rebuilt in 1854 to a size much smaller than its predecessor and is now occupied by the popular Greek restaurant, Lemonia, on Regent's Park Road.

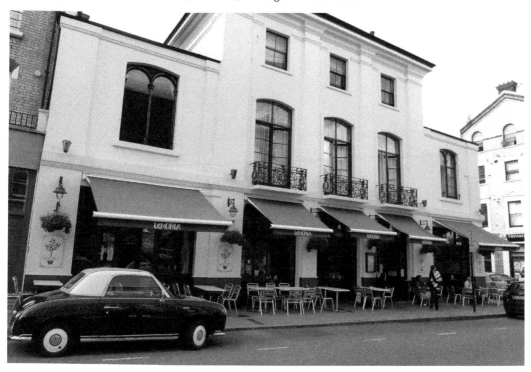

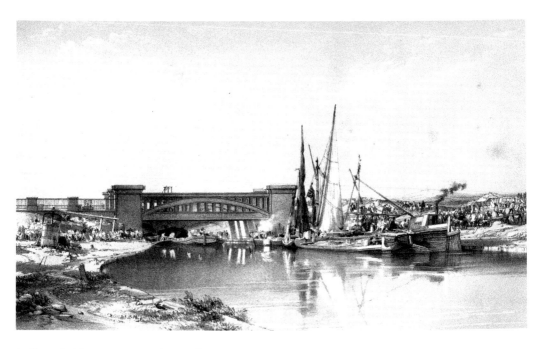

Railway bridge over Regent's Canal

When the railway arrived, the Regent's Canal was already busy with diverse traffic, carried on a variety of vessels – ordinary barges, lighters, sailing barges and narrowboats. J. C. Bourne's print of 1837 shows materials being landed for construction of the winding engine vaults (*ICE*). The deck of the bowstring arch bridge was suspended from the arch ribs, the first railway example of this principle, to give 10 feet (3.0 m) clearance. The original abutments now carry a later bridge, shown below with a Pendolino West Coast Main Line train, backdrop to a busy leisure scene.

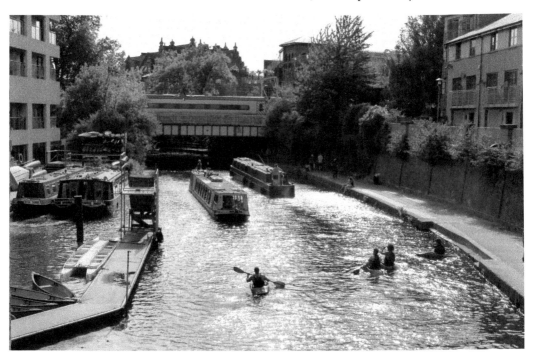

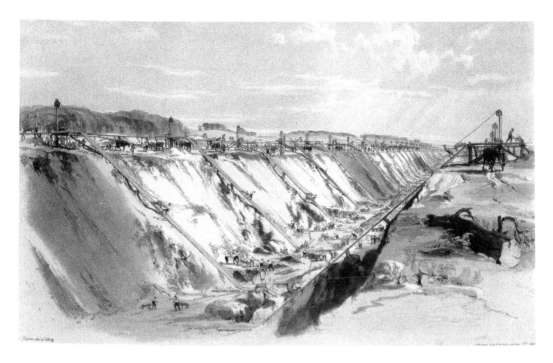

Construction of cuttings

Multiple horse-barrow runs were used to excavate deeper cuttings such as the 40-foot (12 m) deep Primrose Hill cutting and the 55-foot (17 m) deep Tring cutting above (J. C. Bourne, *YCBA*). The horse walked along the cutting, drawing the rope, which was fed via overhead pulleys to the barrow. It was highly dangerous work for the young navvies. The scene near Park Street (now Parkway) on Camden Incline, immortalised in Dickens' *Dombey & Sons,* shows the bridge and the curved retaining walls under construction in September 1836 (J. C. Bourne, *YCBA*). A brickworks is seen on the right. The spoil in the rail wagons is no doubt destined for fill in Camden Goods Station.

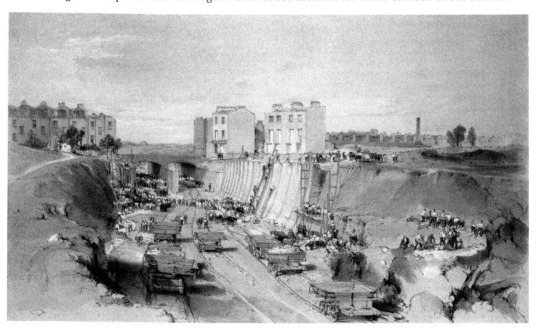

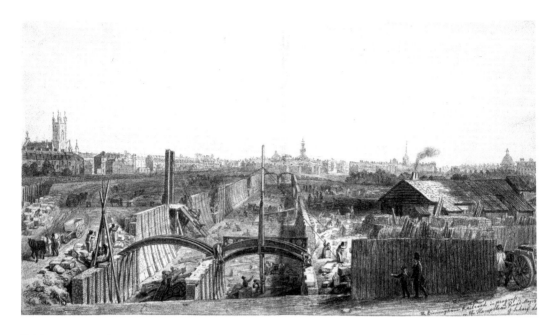

Bridge construction at Hampstead Road

At Hampstead Road, close to Mornington Crescent and at six other road crossings, the ground had to be lowered for rail tracks to pass under the roadways. At these crossings, Camden Incline was graced by handsome stone and iron bridges. The construction work at Hampstead Road is captured by George Scharf (above) in May 1836 (*British Museum*) and J. C. Bourne in September 1836 (*YCBA*). Scharf's drawing shows the cast-iron girders supporting the deck, later faced on both sides (see below and opposite) with roundels. The bridge carried both Hampstead Road and Granby Terrace, which met at right angles. On the left above is the church of St Mary the Virgin in Seymour Street (now Eversholt Street), present to this day.

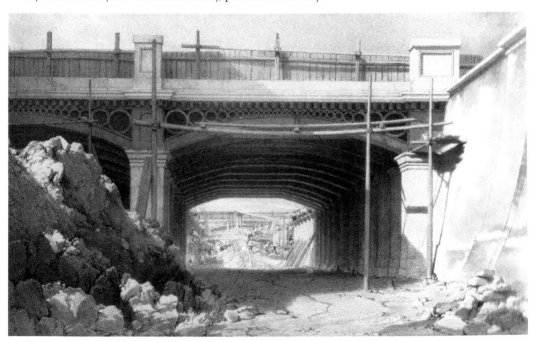

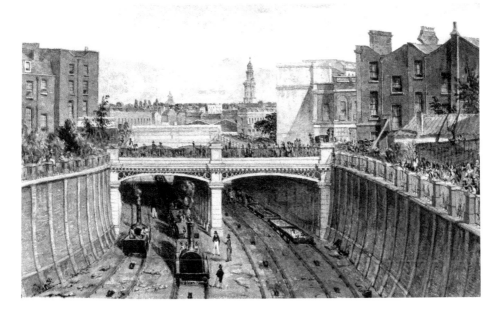

Camden Incline

From July until October 1837, when rope haulage started, a pair of locomotives drew trains to Camden Town, where one would disengage. Robert Schnebbelie's painting of the Granby Terrace side of Hampstead Road Bridge in 1837 anticipated the endless rope on all four tracks (*CLSAC*). The spire of St Pancras New Church is seen just off the line of the cutting. Note also the horse-drawn train on the right set of tracks. T. T. Bury's painting from under Hampstead Road Bridge looking towards Euston in September 1837 shows the actual rope configuration (*CLSAC*). The elegance of the massive curved retaining walls in the 'trench', formed from 16 million bricks, was a notable feature.

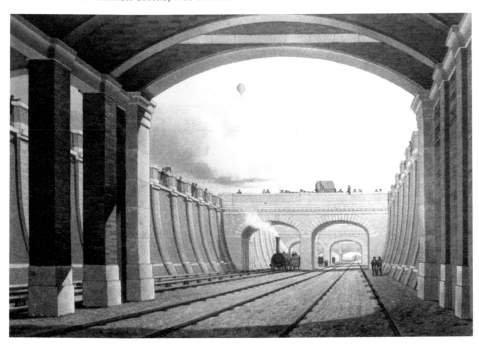

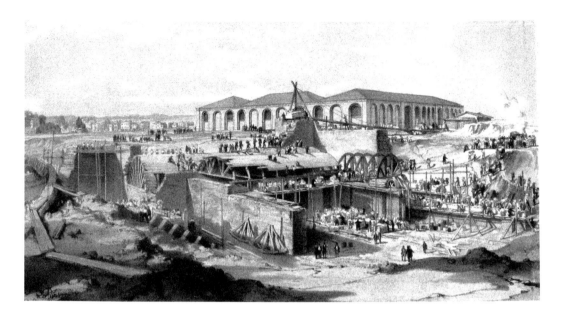

Stationary winding engine vaults

J. C. Bourne uses artistic licence to emphasise the scale of the works under construction in 1837 (*CLSAC*). The two transverse vaults have been timbered and are being clad with bricks. The chimneys are rising in the two far corners. On the right the centring is for the eastern coal stores. Counterforts for the outer wall of the coal stores are evident on the left. The Locomotive Engine House is in the middle distance. The location of the vaults and access to them is shown in plan below. A door on the towpath opens to a tunnel that links with the winding engine vaults. It conveyed anthracite to the vaults from the Regent's Canal (*Map data: Google, Bluesky*).

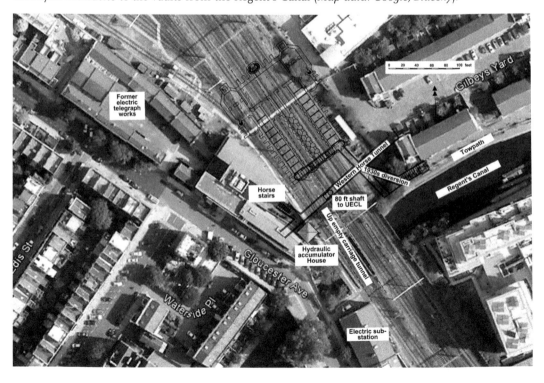

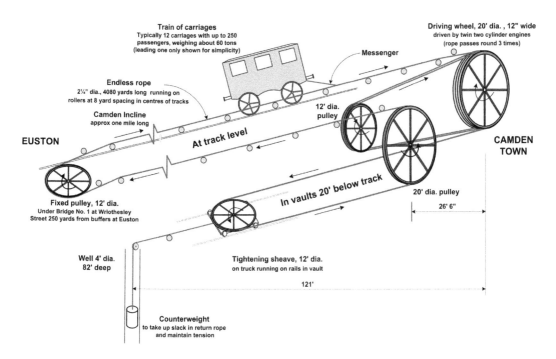

Train of carriages
Typically 12 carriages with up to 250 passengers, weighing about 60 tons (leading one only shown for simplicity)

Driving wheel, 20' dia., 12" wide
driven by twin two cylinder engines
(rope passes round 3 times)

Messenger

Endless rope
2¼" dia., 4080 yards long running on rollers at 8 yard spacing in centres of tracks

12' dia. pulley

Camden Incline
approx one mile long

At track level

EUSTON

CAMDEN TOWN

In vaults 20' below track

20' dia. pulley

Fixed pulley, 12' dia.
Under Bridge No. 1 at Wriothesley Street 250 yards from buffers at Euston

26' 6"

Well 4' dia.
82' deep

Tightening sheave, 12' dia.
on truck running on rails in vault

121'

Counterweight
to take up slack in return rope
and maintain tension

Winding mechanism

Trains were worked up the Camden Incline by an endless rope that ran around a driving wheel and other large wheels and pulleys. At a maximum speed of 20 mph (32 km/h) the driving wheel of 20 feet (6.1 m) diameter rotated at 30 rpm. The tarred hemp rope 4,080 yards (3,730 m) long, then claimed to be the longest unspliced rope on record, was kept taut by means of a counterweight sunk into a well. The 'messenger' used to attach the train to the rope is shown below (*Osborne's London & Birmingham Railway Guide*).

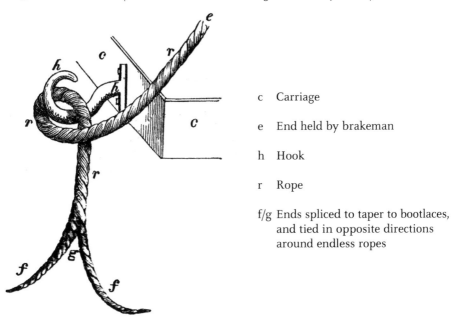

c Carriage

e End held by brakeman

h Hook

r Rope

f/g Ends spliced to taper to bootlaces,
and tied in opposite directions
around endless ropes

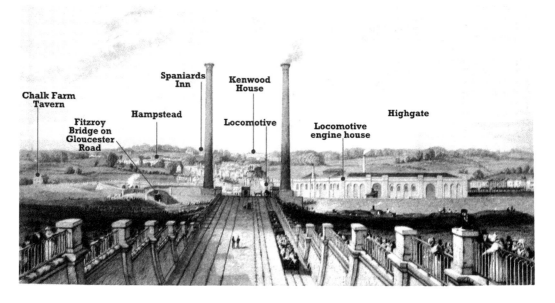

Chalk Farm Tavern

Fitzroy Bridge on Gloucester Road

Hampstead

Spaniards Inn

Kenwood House

Locomotive

Locomotive engine house

Highgate

Rope haulage on Camden Incline

Above, a train descends to Euston at 10 mph (16 km/h) under the control of a brakeman or 'Bankrider'. The locomotive has been detached at the top of Camden Incline. The tapering chimneys of the stationary engine house, 133 feet (41 m) high, were a major feature. Engines, boilers, and winding gear were in vaults below the track. The train in Bury's picture below is being pulled up from Euston by the endless rope and has reached the Regent's Canal Bridge (*CLSAC*). Only the eastern rails were equipped for rope haulage. Both pairs of tracks were retained for operating flexibility, locomotives being used on the western pair if the winding system was out of action.

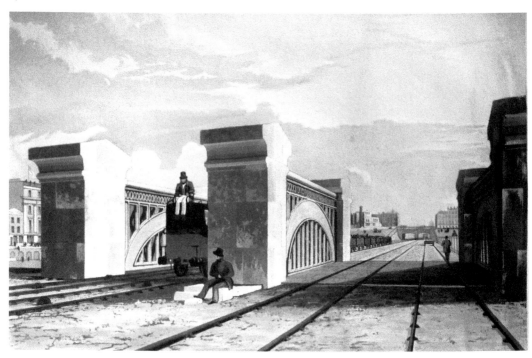

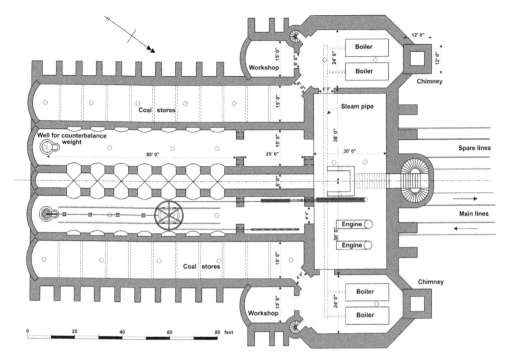

Plan of vaults

The plan of the stationary winding engine house is symmetrical. It measures 170 feet (52 m) long by 135 feet (41 m) wide. Only the eastern half of the engine house was equipped with machinery. The western half, intended for the GWR, received only boilers and steam pipe. Little of the structural fabric has changed since the vaults were built. The church-like size and vaulting is seen in two images (*BWCP and Nick Catford*) looking from the western rope tightening vault. The well for the counterweight is at the far end. The underground vaults built by Stephenson to house the winding engines have survived very well and are structures on a truly majestic scale.

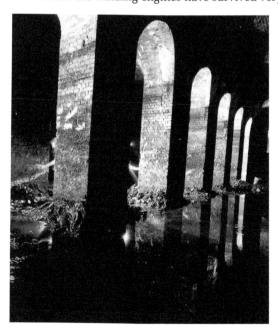

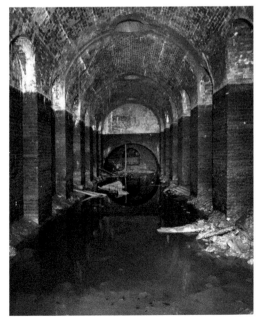

21

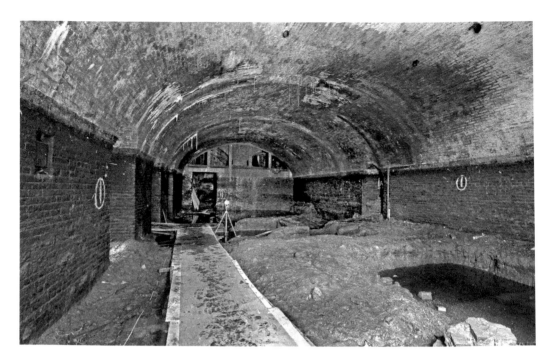

Vaults dewatered for inspection

The engine room, 72 feet (22 m) long by 30 feet (9.1 m) wide, housed two 60 hp condensing beam engines, made by Lambeth firm Maudslay, Sons & Field, which drove the 20-foot (6.1 m) driving wheel. Below left, the sheave room, where the 20-foot (6.1 m) return wheel was located with the rope passing through the roof. The rope to the tightening sheave passed through the two low level openings seen each side of the arch. When not de-watered the water level is at the distinct lines half way up the walls. Below right, the central vault (*all Nick Catford*).

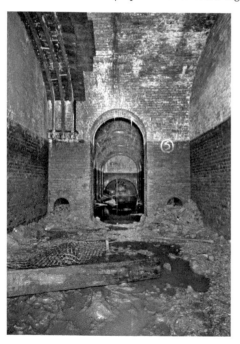

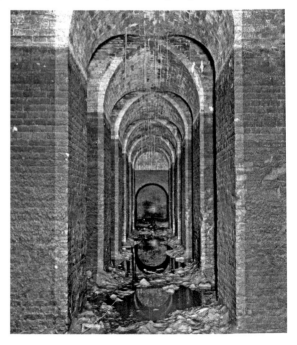

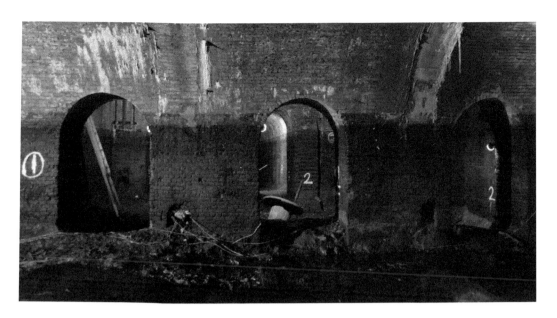

The view above is from the engine room looking towards the openings to the rope tightening vaults and the central vault. The upper part of the engine room vault clearly shows where the driving wheel ran, below which are openings for the rope to pass into the sheave room opposite. The eastern coal store vault is shown below (*Nick Catford*). No account of operations in the winding engine vaults has been found. It is believed that anthracite delivered to the towpath by barge was moved onto trucks and transported on light rails from the towpath to be fed by chute or side-tipped into the vaults.

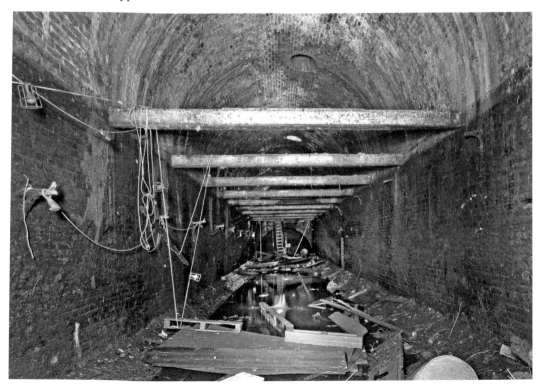

The end of rope haulage

Rope haulage ceased on 14 July 1844. Within eighteen months, the equipment was decommissioned and removed from the vaults through the open boiler room. The equipment was sold, the two engines going to a flax mill and a silver mine in Russia. The chimneys were demolished. Supporting pillars were added (below) and the boiler room roofed over. Part of the roof that was added has since partially collapsed (*BWCP*). Locomotives continued to be taken off southbound trains at Camden until 1857, carriages descending to Euston under the control of bankriders. The vaults remain empty and, although flooded, are generally in sound condition and continue to support the main line.

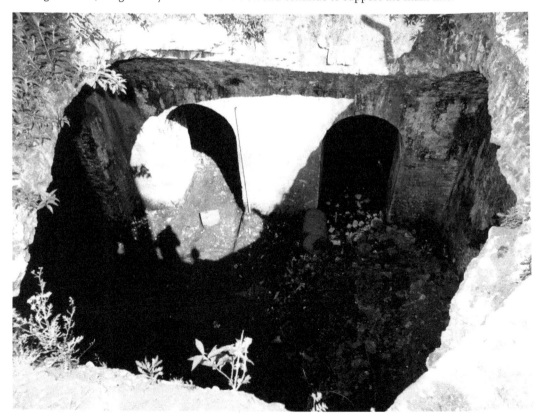

3: L&BR Camden Goods Station

Camden Goods Station was originally intended as the London terminus of the L&BR. The area initially purchased from Lord Southampton was 25 acres (10 hectares) on the north side of the Regent's Canal. Considered unwarranted by many directors when proposed by Robert Stephenson, it soon proved inadequate. Further land was subsequently purchased on the south side of the Canal and on the north bank between Southampton Bridge and the present Roving Bridge. These additions created a goods yard of 33 acres (13 hectares), the area of which remained essentially unchanged for over 100 years to the end of the steam era in 1962.

To carry the main line over the Regent's Canal with sufficient height for the passage of barges, the level of the rails had to be raised up to 15 feet (4.5 m) above natural ground level. This 'railway level' was extended over the Goods Station area, requiring vast quantities of fill. The fill was obtained primarily from Primrose Hill Tunnel, from its 40-foot (12 m) deep approach cutting and from Camden Incline, predominantly blue London Clay.

This difference between the railway level and ground level is fundamental to understanding the various features of the Goods Station. It is evident in all the following locations:

- the stairs from ground level up to the Performance Space (where the former locomotive turntable was located) at the Roundhouse;
- the curved ramp or 'horse creep' and the ramp or 'horse road' along the retaining wall, both of which lead from ground level in Stables Yard to the entrance at first floor level of the Horse Hospital;
- the level of the Interchange Warehouse above Camden Lock Place;
- the heights of the Great Wall of Camden (page 2) and the retaining wall alongside the Regent's Canal towpath between Southampton Bridge and Fitzroy Bridge;
- the level of Morrison's car park above Chalk Farm Road.

The first Camden Goods Station in 1839 included:

- the stationary engine house with boilers, condensing engines, winding gear and chimneys;
- a locomotive engine house capable of accommodating fifteen engines, together with fitting shops and offices;
- eighteen coke ovens to make smokeless fuel for locomotives, with a tall chimney;
- two goods sheds, stores and a wagon building and repair shop;
- cattle pens and stabling for fifty horses;
- offices.

The goods sidings were constructed in a curious pinnate form, with spur sidings branching out on either side of a 'stem' at angles of about 60 degrees. Both sidings and the No. 1 Goods Shed, on the southern side of the stem, were supported by vaults that were arranged to fit within these lobes. Stables there were rented by Pickford & Co. and other tenants by 1840.

The influence of public carriers of goods, of which Pickford was the largest, resulted in their obtaining the rights of carriage and distribution of goods on the L&BR. From the start of 1839 freight was hauled between London and Birmingham for Pickford and two other carriers that became forwarding agents for the L&BR. From 15 April that year similar services were offered to other firms. Goods sheds had therefore to be provided for each individual carrier.

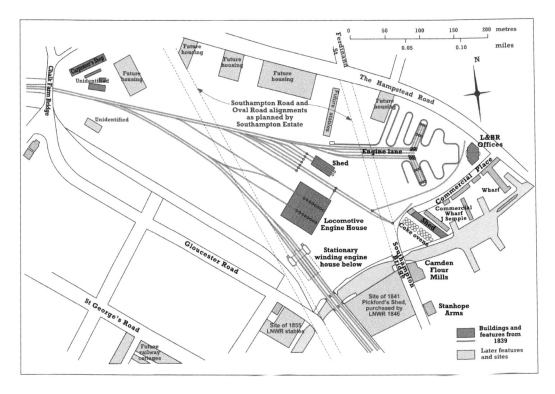

Camden Goods Station 1839

The plan shows the original goods station plus some early additions. The curious kink in Gloucester Road (originally Southampton Road, now Gloucester Avenue) at Fitzroy Bridge over the Regent's Canal was caused by its diversion to avoid crossing the railway. Another curiosity, the pinnate form of retaining wall, is clearly shown on plan and in George Scharf's sketch of June 1837 (*British Museum*). No completed painting of the goods station has been found.

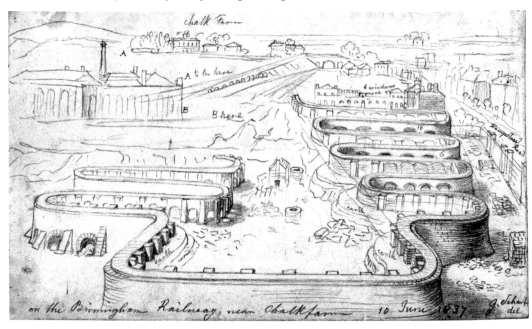

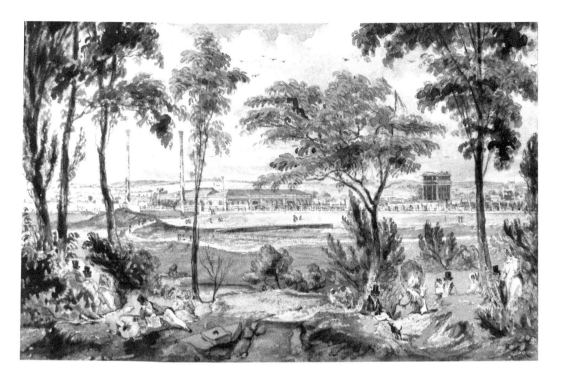

Camden Goods Station from Regent's Park

R. B. Schnebbelie's watercolour of 1837 shows the L&BR on embankment, the chimneys of the winding vaults, and the locomotive engine house (*CLSAC*). The tall building is the Stanhope Arms, expected to be the hotel for a London terminus at Camden Town. The foreground shows the Cumberland Market Branch of the Regent's Canal that led to the Cumberland Basin (below) and Hay Market that took over from that in the West End in 1830 (*Map data: Google, Bluesky*). This arm of the canal was filled with bomb rubble during WWII, leaving only a short section as a mooring basin. The view from the location above now overlooks the car park for London Zoo.

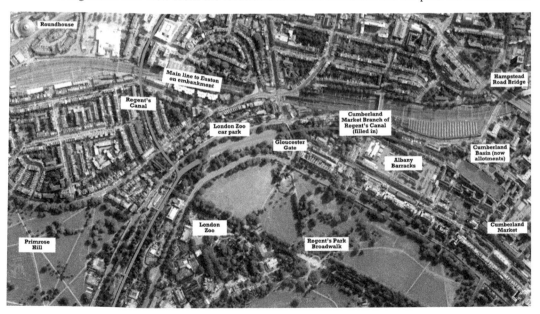

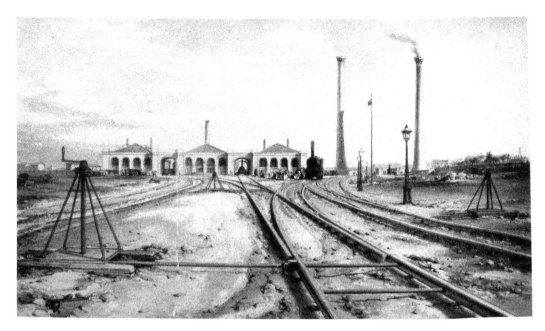

Locomotive engine house

The Locomotive Engine House is also shown on pages 15, 19 and 27. The main line to Euston curves to the south between the chimneys of the winding engine vaults. Points in the foreground directed locomotives to the top of the Incline. The engine house was built on the 'up' side (into London). Rail tracks led to entrances to the three engine house units and onto turntables, by which locomotives were turned into their parking bays (*CLSAC*). Emerging from the engine house is a Bury-type 2-2-0 locomotive, being directed to the goods station by the points operator *(ICE)*.

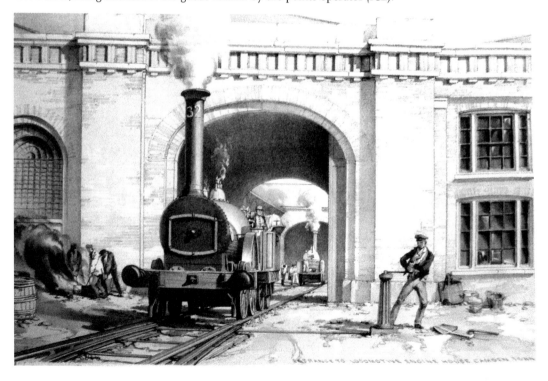

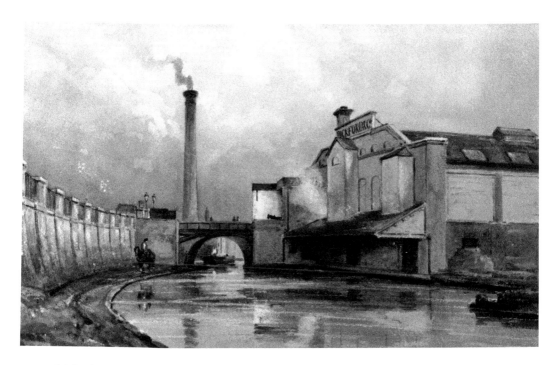

Pickford and goods interchange

Pickford & Co. was the largest bulk carrier of goods on the canal network, and obtained rights of carriage and distribution on the L&BR. It built a large goods shed 'twice the area of Westminster Hall' on the south side of the canal, designed by Lewis Cubitt to facilitate transfer of goods between road, rail and canal, the first such interchange warehouse, which opened in December 1841. The shed had extensive stabling in the basement and a rail connection with the goods station on the north bank. The chimney above was that of the coke ovens. The white building was Camden Flour Mills (*London Canal Museum collection*). In today's scene the towpath retaining wall remains with its railings restored, now facing Lock House.

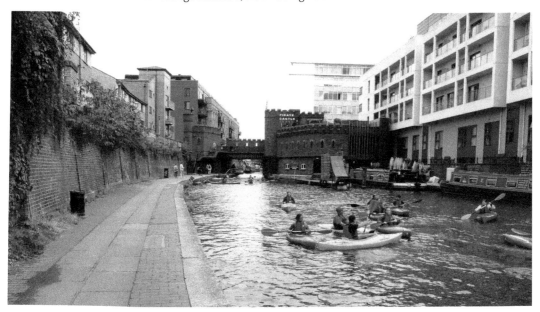

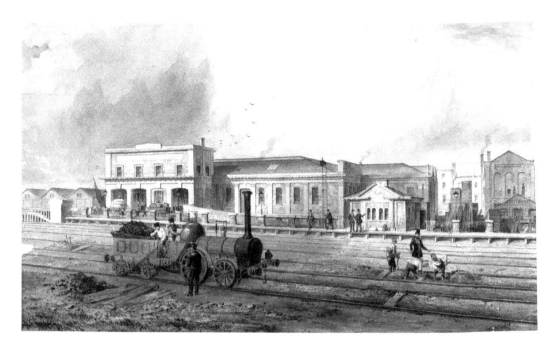

Pickford enlarged their shed in 1845, when a reduction in carriage rates caused a major increase in traffic volume. W. H. Prior's 1848 watercolour shows the new western façade stepped back twice from the canal frontage where a sailing barge is glimpsed. Beyond the four tracks and the Bury-type 2-2-0 locomotive is the short-lived Camden Station passenger platform with ticket collectors' office and bankriders' waiting room built in 1846. Collard & Collard's first piano factory on Oval Road is on the right (*NRM/SSPL*). Lock House now occupies the site of Pickford's warehouse.

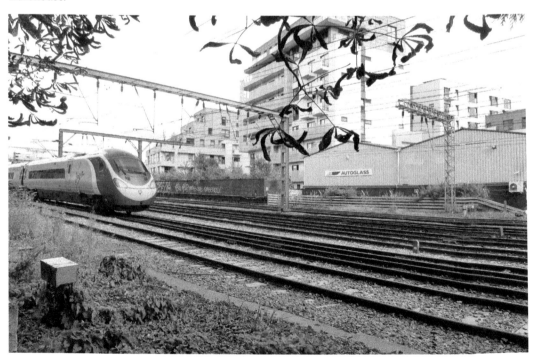

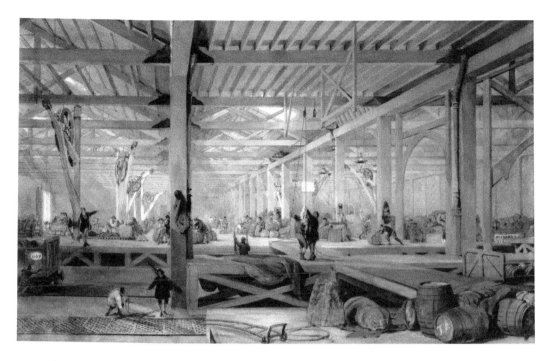

The scale and organisation of Pickford's operations can be imagined from the image (*NRM/SSPL*). Rail tracks, sidings and turntables criss-cross the building; cranes and hoists assist with loading and unloading; goods are stored at a level that aids loading into rail wagons. Below, dramatic scenes during a fire in June 1857, said to be the most destructive in London for quarter of a century, as over 100 horses released from their stables in the basement bolt in panic along Oval Road (*CLSAC*). The warehouse was rebuilt by LNWR but without stabling. A second fire in November 1867 removed much of the roof with its glass louvers. This caused Pickford to abandon its Camden shed.

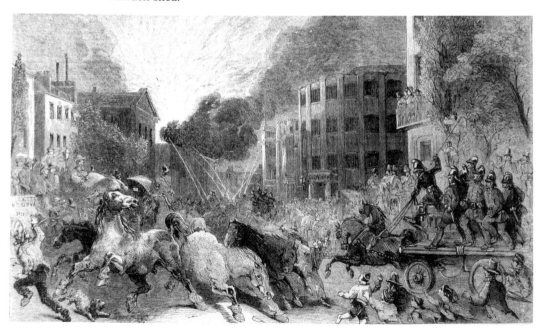

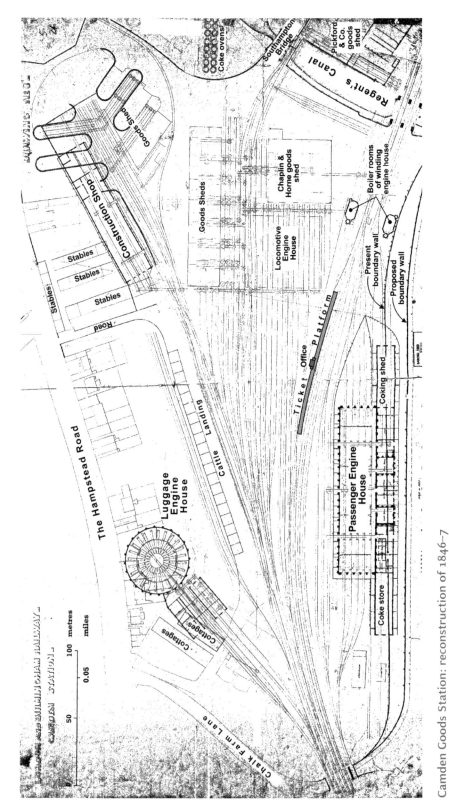

Camden Goods Station: reconstruction of 1846–7

The ticket platform and ticket collector's office is shown on the up side where locomotives were detached before reversing to the back of the train to provide an impetus down Camden Bank, where control passed to the Bankrider. Once the use of winding engines ceased the ticket platform was moved to the other side of the canal bridge. The 1846 reconstruction was a major one involving several new buildings and the separation of goods from passenger services (*adapted from Network Rail*).

4: London & North Western Railway to 1900

In 1846 the L&BR amalgamated with several companies to become the London & North Western Railway (LNWR). It was immediately faced with reconstruction of the Goods Station, dictated by the rapid growth of passenger and goods traffic and the increase in speed of passenger trains. The longer, more powerful locomotives could no longer be accommodated in the original shed, a space now needed for goods traffic. The reconstruction was the responsibility of Robert Dockray, Resident Engineer to the LNWR.

The need for separation of goods from passenger services was accentuated by a fatal accident in July 1845 when an early morning mail train approaching Chalk Farm Bridge in heavy fog collided with a goods train that was being assembled but whose departure was delayed. There was a major outcry in the national press.

Two engine houses were built on opposite sides of the main line near the western extremity of the Goods Station site (see plan opposite), one for passenger locomotives on the down side and the other – which we know as the Roundhouse – for goods engines on the up side. Passenger trains were now passing at full speed through the station and this arrangement reduced the risk of collision.

The Passenger Engine House was a rectangular building 400 feet (122 m) by 90 feet (27 m) complete with coking shed, coke store, offices, stores and fitters shop. Steam engines powered the workshop machinery and pumps for water supply, the water being pumped from an artesian well. Much altered over time, this shed survived until 1966. The structural form of the Roundhouse, 160 feet (49 m) in diameter, was influenced by the limited space on the north side of the yard. It had similar coking facilities.

The two tracks from Camden Station to Primrose Hill Tunnel were augmented by two additional tracks on the south side which became the down side lines, the tracks being merged to go through the tunnel. This situation continued until a second tunnel was constructed to serve the main line, the original tunnel then serving the 'slow' lanes. The new tunnel came into use on 1 June 1879.

A fifth track was provided to allow longer goods trains to be assembled with less risk of collision and a new bridge was constructed on Chalk Farm Lane to span the five tracks. Completed in March 1847, the bridge used early wrought-iron box girders to Robert Stephenson's general design. The first such bridge he erected, it may have been the first such bridge anywhere of a significant span.

Included in the 1846–7 reconstruction was a Construction Shop for building and repairing goods wagons, under the supervision of Edward Bury as Locomotive Superintendent. This stood on vaults covering an acre (0.4 hectare) used for stables and storage. A 600-foot (183 m) long cattle landing area with cattle pens was erected near to the Roundhouse.

The North London Railway (NLR) arrived in 1851. The tracks were aligned over the original goods sidings, requiring the removal of the railway offices as the line approached the bridge over the Hampstead Road.

The Roundhouse was taken out of service in c. 1855 to permit a second major re-planning and enlargement of the Goods Station, in which the NLR was moved northwards, blocking approaches to the engine shed. Goods sheds and stabling were much expanded. The coke ovens were removed.

The 1860s saw another major phase of construction with the main goods shed built in 1864 and new goods offices in 1866. These offices were much altered and enlarged over time.

As the economy grew, goods brought by the LNWR were dispersed to every part of London. In October 1866 there were 100 locomotives stationed at Camden: thirty-three passenger, four banking, forty-six main line goods, fifteen shunting, and two ballast engines. By the 1870s Camden was a major transport hub in a sea of railway lines handling up to thirty goods trains to and from 'the country' each night.

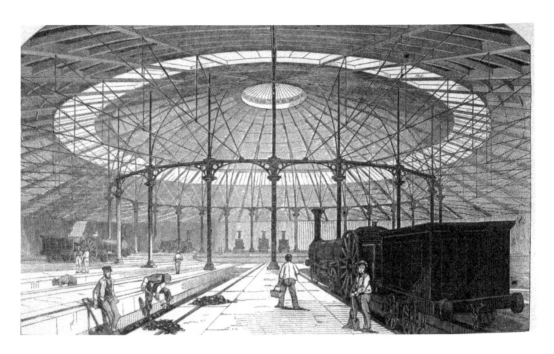

'The New Great Circular Engine House'

The Roundhouse was built in 1847 as a shed for goods locomotives. It could hold twenty-three engines, one between each pair of columns. In the centre was a turntable 36 feet (11 m) in diameter onto which engines were run to be turned into their berths (*Illustrated London News*). The twenty-fourth track was for entry and exit. It was taken out of service because of the radical remodelling of the yard in 1855–6, becoming a grain and potato store in the 1860s. In 1870 W. & A. Gilbey took it over as a bonded warehouse for whisky in barrels from their Highland distilleries, a use it maintained for almost a century until 1964. The elegant cast iron columns now give the Performance Space its character (*Stuart Leech*).

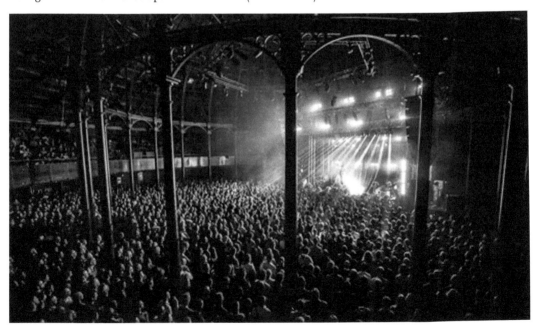

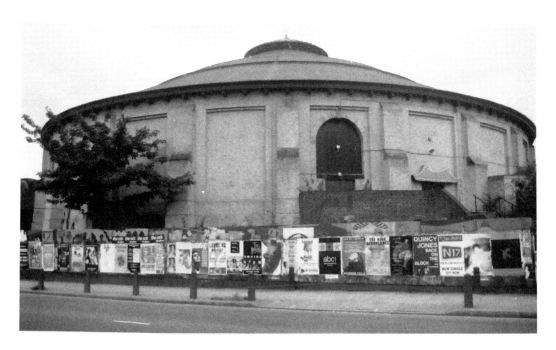

The Roundhouse

The Roundhouse was relaunched in 1966 with London's first all-night rave and soon became an iconic rock venue, hosting all the leading stars and groups. It acquired a reputation for cutting-edge theatre which gradually displaced rock as noise and licensing restrictions took their toll. It closed in 1983 and had a chequered history for the next twenty years until the 2004–6 regeneration. The view above is from 1975, during its period as rock music venue and theatre in the round (*Malcolm Tucker*). Below, the original roof stripped of its glazed section in the early days of conversion works in 2004 (*Celia Kelly*).

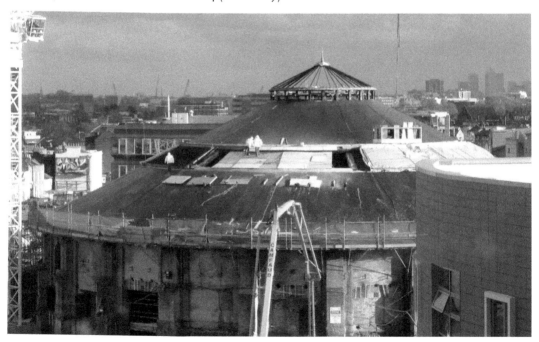

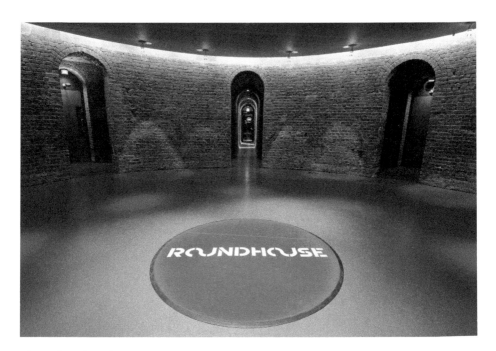

The Hub and vaults

The Roundhouse is founded on brick vaults at natural ground level that raised the turntable and engine service bays to railway level. Central to these vaults is the Hub, now a rehearsal space. From the Hub eight passages radiate to an inner circular passage (below left) from which twenty-four passages, corresponding to the locomotive bays, radiated to an outer passage. Many such passages remain (below right), while others have been adapted for studios and workshops as part of the Roundhouse's new role as performing arts venue and creative centre for young people (all *The Roundhouse*).

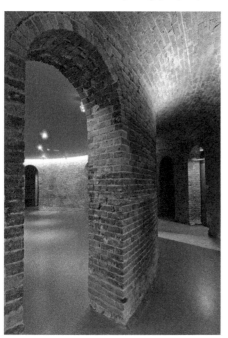

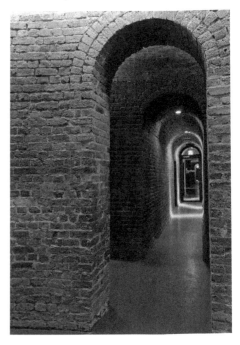

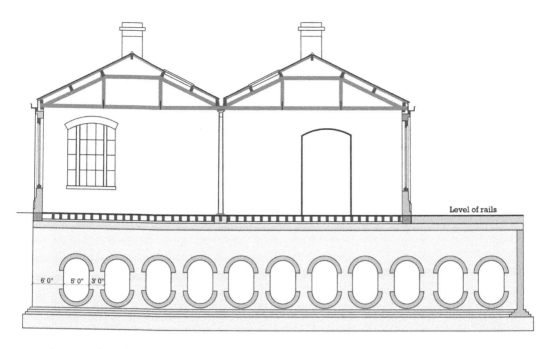

Level of rails

6' 0" 5' 0" 3' 0"

Construction Shop and Camden Catacombs

The 1846–7 reorganisation included a goods wagon construction and repair shop 436 feet (133 m) by 70 feet (21 m), brought up to the level of the rails on vaults used for stables and general stores. Above, cross section through one of the twenty-five main vaults. There was room to build and repair 100 wagons at a time. The workshop was taken down eight years later to make way for realignment of the NLR but the vaults, already occupying 0.7 acres (0.3 ha), were later extended (p.53) to create coal drops. Gilbey's image from 1910 shows 'The Catacombs', as they were already known, holding 8,000 'pipes of wine'. There were tales of visitors losing their way in the maze.

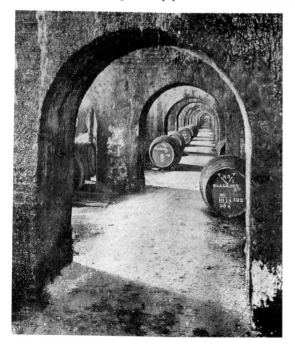
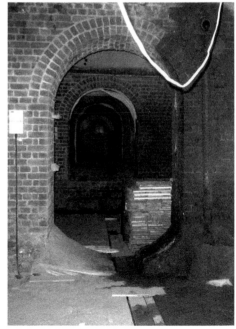

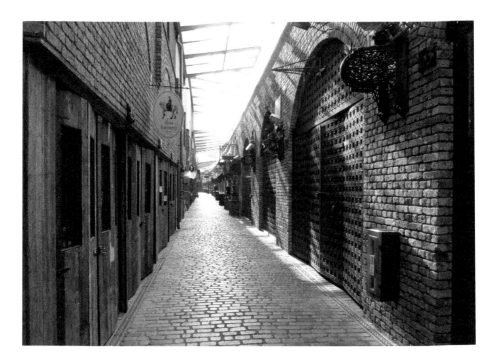

The 1846 vaults or 'Camden Catacombs' were refurbished and cut back to the line of the NLR as part of the redevelopment of Stables Market in 2009 as seen above and on the previous page. A passage was created between the vaults on the right and the new building in Stables Market on the left. The scene is rarely so tranquil. Each of the main vaults, which measure 12 feet (3.7 m) from ground level to the crown, now houses a market retail outlet. The transverse vaults seen below are all filled for display purposes.

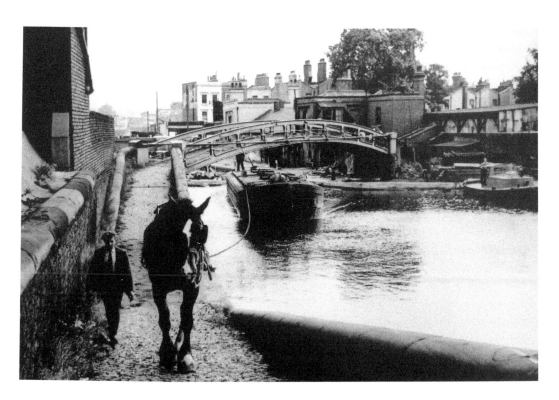

Roving Bridge

The 'Roving Bridge', built in 1846, carried the new towpath to the south side of the canal to avoid bridging over the other two docks. It is of cast-iron construction, effectively two arches, one above the other, with the upper one constrained by tensioned rods. The cobbled paving and massive gritstone parapets of the approach ramps are very attractive (*Northside Archives*). Stables were built alongside the Lock Keeper's Cottage (*English Heritage*). Grooves in the cast-iron parapet reveal the forces required to haul barges from the southern lock to the north bank.

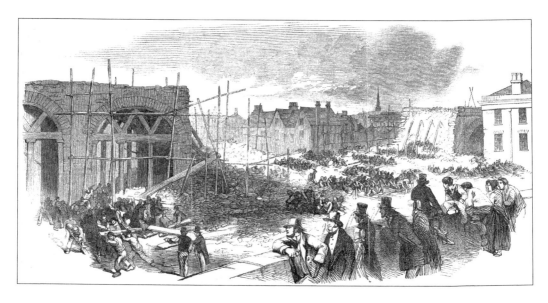

North London Railway

The rail freight connection to London docks was made with completion in 1851-3 of what became the North London Railway (NLR), creating a real rival to the Regent's Canal. Some arches near the river Fleet in Camden Town collapsed during construction in November 1849 *(Illustrated London News)*. Below, the NLR in 1976 viewed from the roof of Gilbey's No. 4 Bond, looking across to Gilbey's Export Warehouse and the Hampstead Road Junction signal box *(David G. Thomas)*. Two railway sidings served the Interchange shed (right): one entering the building, the other the open shed alongside with glazed roof.

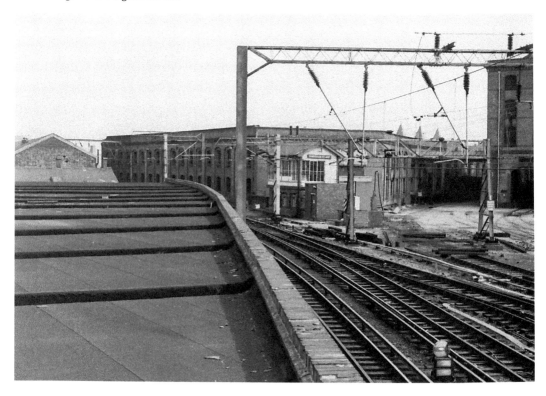

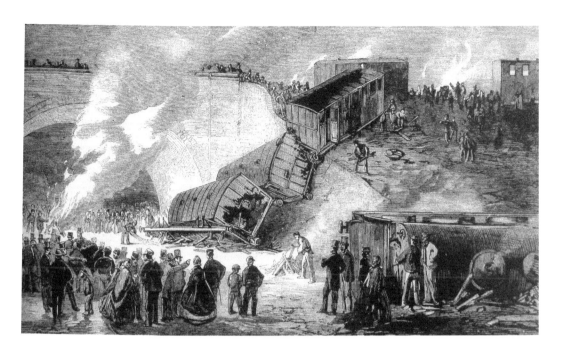

The NLR proved very successful for carrying city workers commuting from the new estates, but the traffic aggravated congestion on the main line. Built to relieve it, Hampstead Junction Railway ran from the NLR at Camden Town to Willesden thus allowing NLR trains to bypass the main line. It opened in 1860 with stations at Kentish Town (Gospel Oak), Hampstead Heath, Finchley Road and Edgware Road (Brondesbury). Kentish Town was the scene of a fatal accident in 1861 (*Illustrated London News*). Below the NLR crosses Chalk Farm Road at Camden Lock's iconic bridge (*Eric Braun*).

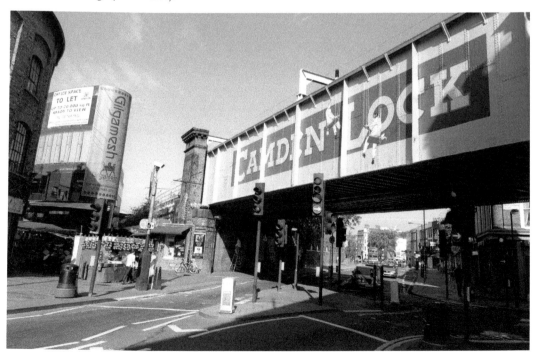

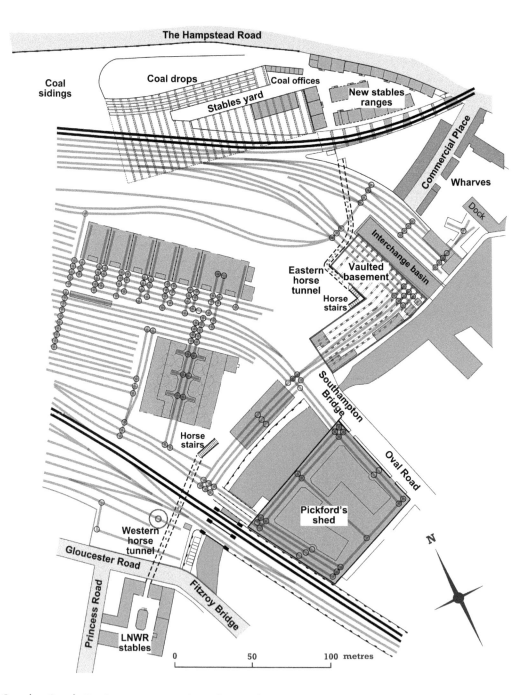

Camden Goods Station: reconstruction of 1854–6

The Goods Station was soon short of space again as its business grew rapidly. The NLR was moved northwards requiring the removal of most of the Construction Shop. New retaining walls were built to allow the railway level to be extended along both the Hampstead Road and the Canal. This helped create a coal yard with sidings and coal drops. The cattle pens were relocated to Maiden Lane. Five new stables ranges were built (including the stables on Princess Road) with horse tunnels connecting them to the railway lands. The basement west of the Interchange basin was built as beer vaults. These features are described in Chapters 5 and 6.

Hydraulic power

The LNWR installed the first hydraulic cranes at Camden Goods Station in 1853. The 40-foot (12 m) high hydraulic accumulator tower, built to supply water under pressure to the hydraulic systems, principally cranes and capstans, dates from later that decade. It is believed to be the oldest LNWR accumulator tower to survive. The lower part of the tower was altered to accommodate new rail tracks around 1912. It now houses a staircase and lift shaft for the new development at 42 Gloucester Avenue, the courtyard of which retains horse stairs (above right). These led from Allsopp's stables to the Western Horse Tunnel, which carried hydraulic power to the Goods Station and still carries electric cables (below).

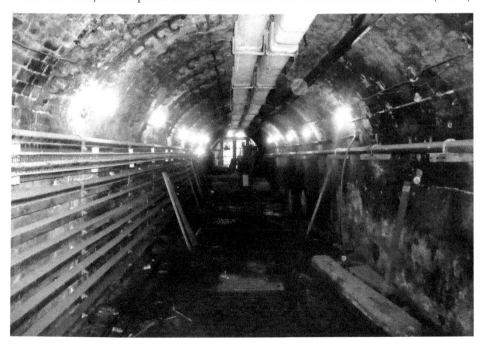

The electric telegraph

24 July 1837 saw the first use of Cooke and Wheatstone's electric telegraph, only patented the previous month, when Robert Stephenson introduced it on a trial basis for the Camden Incline. But he decided to retain the pneumatic telegraph. In 1846 the Electric and International Telegraph Company, which owned the Cooke and Wheatstone patents, was incorporated for public telegraphic communications using railway routes as corridors for the overhead lines. Their Gloucester Road works, built in 1858, housed an extensive factory carrying out a great variety of skilled operations. The company was nationalised and taken over by the Post Office in 1870. The single storey building facing Gloucester Road was replaced by the present three-storey building in *c.* 1871.

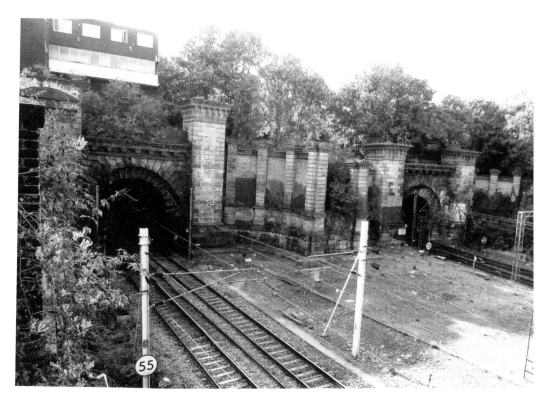

Second Primrose Hill tunnel

The southern tunnel, dating from 1879, was built by William Baker, Engineer-in-Chief of the LNWR. The portal replicates the design of the original but is a little taller as the ground rises to the south. It is the entrance to the 'fast tunnel' used by WCML trains. The tunnel forms an arc south of the original tunnel; midway the vent shaft rises dramatically from a garden in Wadham Gardens. The vent shaft for the northern tunnel is behind louvers, accessed from the Marriott Hotel car park.

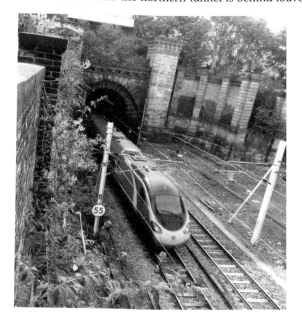

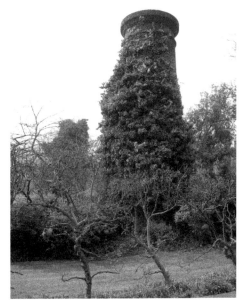

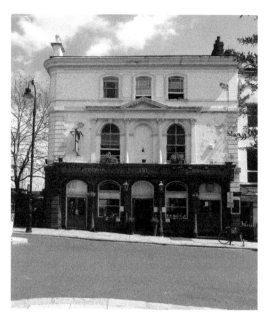

Off shift

Camden Passenger Engine Shed (pages 70–72) stretched for more than 700 feet (215 m) from the turntable behind the Pembroke Castle (above left) to well beyond the Lansdowne (above right). Many rail workers lived nearby and used the footbridge in Dumpton Place to get to the Engine Shed. The Lansdowne was open when they came off shift in the early hours. Besides some six pubs on the west side of the tracks, including The Engineer (below left), many others clustered along Chalk Farm Road and Jamestown Road. Camden also boasted a Windsor Castle, an Edinburgh Castle, a Carnarvon (*sic*) Castle and a Dublin Castle to meet the thirst of workers from all parts of the realm.

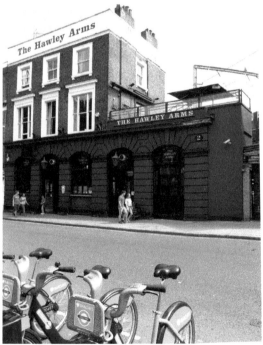

5: Industry and commerce

The first commercial establishments in the area settled along Commercial Road (now Camden Lock Place) and James Street (now Jamestown Road) with wharves fronting onto the docks that had been created in 1816 with the arrival of the Regent's Canal. The goods they handled were not only for the construction activities that were gathering pace as London expanded rapidly, such as timber and stone, but also bulk goods for domestic and retail markets, such as coal and ice.

With the arrival of the railway, higher value goods could be moved more quickly and reliably. Camden Town became a centre from where goods brought by the LNWR were dispersed by road to every part of London. Major carriers such as Pickford and Chaplin & Horne established themselves at Camden Goods Station and goods interchange developed into a high growth business. The railway company provided facilities for these carriers, as it did for Allsopp the Burton brewers that also created a Camden base.

W. & A. Gilbey Ltd, formed in 1857 as importers of inexpensive wine, established its head office at the Pantheon in Oxford Street (site of the present Marks & Spencer) in 1867. In 1869, it was persuaded by LNWR to move its warehouse to Camden. Gilbey took a twenty-one year lease on Pickford's former warehouse, by now a grain and potato market, and twenty year lease from 1870 on the Roundhouse, by now a grain and potato store. The warehouse became Gilbey's 'A' Shed and the Roundhouse became its No. 3 bonded warehouse. Both buildings needed substantial investment. Gilbey also took over much of the extensive vaulting under the goods station, primarily under the former Construction Shop, which provided an excellent environment for storage of wine (page 37).

With over 1,000 employees, Gilbey became the major employer in the area as well as the largest drinks firm in the world. By 1914 its premises in Camden covered a floor area of 20 acres (8 hectares) with the bottle and bonded warehouses capable of storing 800,000 gallons (3.7 million litres). Daily a whole train, the Gilbey Special, left for the docks to supply distant markets around the world. Gilbey moved its operations from Camden to Harlow in 1964.

Camden Town's locational advantages enabled it to become a centre of the piano industry. Collard & Collard were the oldest of the well-known piano manufacturing firms of the St Pancras area, having patented an affordable upright 'square' piano in 1811. Other firms included Hopkinsons, with a factory in Fitzroy Road, and Chappells factory in Belmont Street. In addition to the large companies that assembled pianos there was a cluster of smaller companies supplying parts and services to the industry.

The largest business located at Camden Goods Station was, of course, the railway. The amalgamation of companies that formed the LNWR had briefly created the greatest joint stock company in the world. The Railways Act which came into effect on 1 January 1923 to give rise to the LMS from the LNWR, the Midland Railway, the Caledonian Railway and a number of smaller railways, once again created the largest joint stock company in the land.

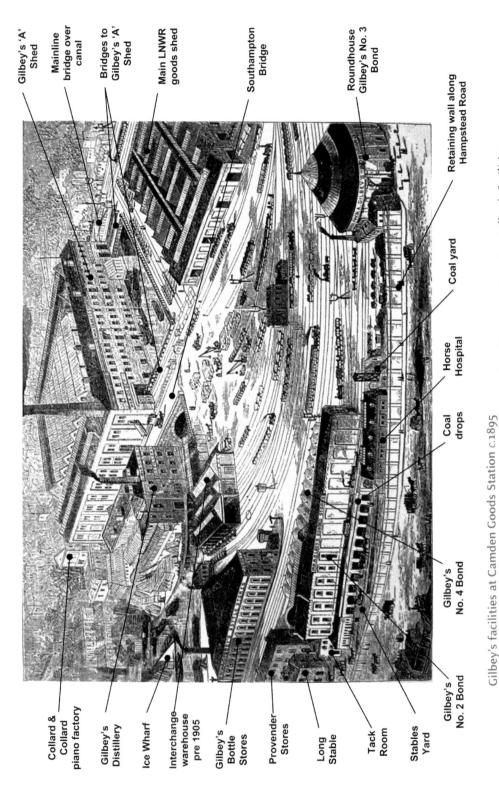

Gilbey's 'A' Shed

Mainline bridge over canal

Bridges to Gilbey's 'A' Shed

Main LNWR goods shed

Southampton Bridge

Roundhouse Gilbey's No. 3 Bond

Retaining wall along Hampstead Road

Coal yard

Horse Hospital

Coal drops

Gilbey's No. 4 Bond

Collard & Collard piano factory

Gilbey's Distillery

Ice Wharf

Interchange warehouse pre 1905

Gilbey's Bottle Stores

Provender Stores

Long Stable

Tack Room

Stables Yard

Gilbey's No. 2 Bond

Gilbey's facilities at Camden Goods Station c.1895
The engraving from the *Gilbey Book of Wines, 1896* uses artistic licence to dramatise Gilbey's facilities.

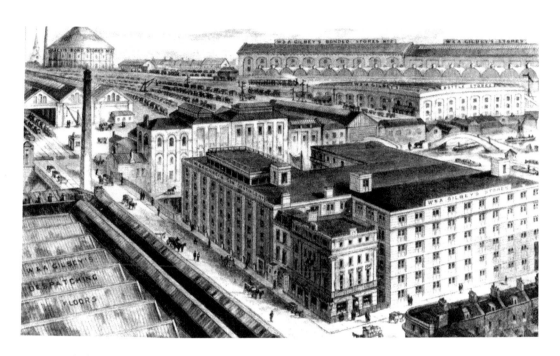

Bonded warehouses

A bird's eye view shows Gilbey's facilities including the Roundhouse or No. 3 Bond, used for storage of whisky from Gilbey's highland distilleries, No. 2 Bond of which only the 'Gin House' remains, and No. 4 Bond (under the round corrugated roofs). No. 1 Bond was in the 1856 vaults under the railway offices and west side of the Interchange Basin where wooden sleepers used for barrel runs (below) were still evident in 1987 (*Nick Catford*). No. 5 Bond was under the arches of the NLR at Camden Town station. Bonds 1, 2 and 4 were interconnected by passages under the railway. The Stanhope Arms is seen on the corner (compare with image 60 years earlier on p.27).

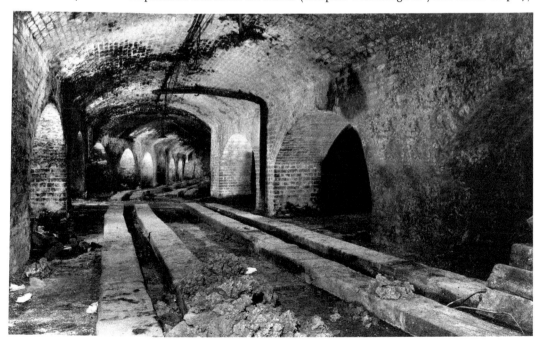

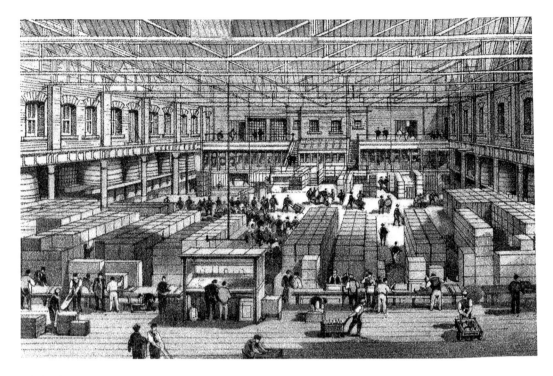

'A' Shed

In 1869 Gilbey took over the former Pickford warehouse that became their 'A' Shed and largest facility for vatting, blending, bottling and packing of wines and spirits. Two railway sidings served the shed, crossing the Regent's Canal from the Goods Station. In 1894 three tunnels were constructed under Oval Road from the former gin distillery. Above, the Packing and Forwarding Department on the ground floor (*Diageo Archive*). Below, Gilbey's four-in-hand with coach alongside the 'A' Shed (*Diageo Archive*). The 'A' Shed was demolished in the late 1960s. The site was redeveloped in 2005-8 as the present Lock House.

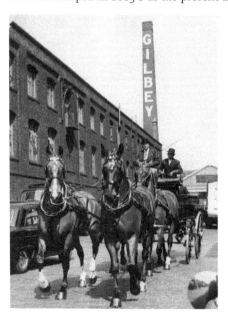

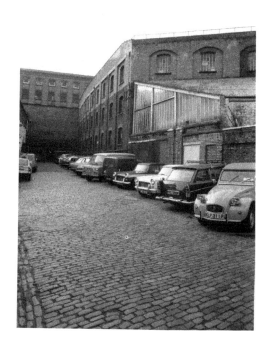

Export Warehouse

The Export Warehouse, or triangular Bottle Stores, was built in the 1880s fronting Commercial Place (*Malcolm Tucker*), taking over No. 2 Bond's export bottle role. It had its own siding from the NLR where wagons were assembled into the Gilbey Special which left daily for the Docks. Below a rail wagon loaded with barrels is waiting in a siding. Note the capstan and ropes used for moving wagons. The Export Warehouse was destroyed by fire in 1985. The site has been occupied since 2006 by the Gilgamesh building (above right) in what is now Camden Lock Place.

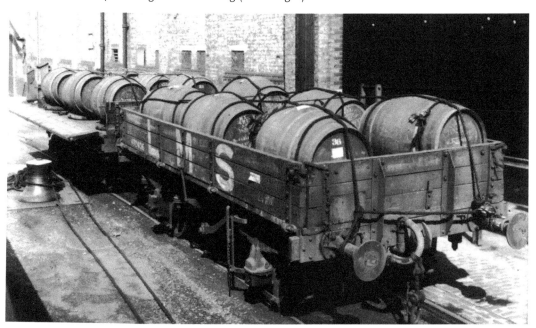

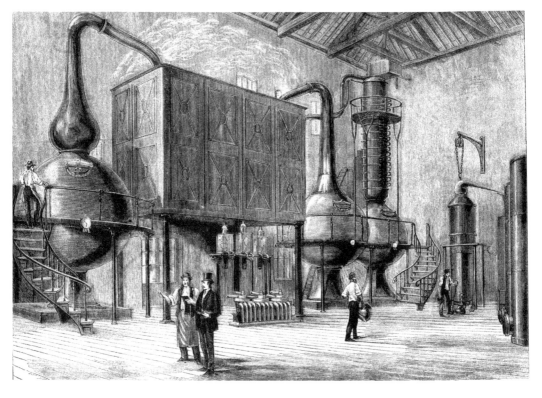

Gin distillery and Gilbey House

Gilbey established a gin distillery in 1872 opposite the 'A' Shed in Oval Road on the site of the former Camden Flour Mills (*Diageo Archive*). The distillery site was later incorporated partly into Gilbey House in Jamestown Road, formerly the Bottle Warehouse built by William Hucks in 1896, and partly into the building now known as Academic House, formerly Gilbey House *(below)*. Built in 1937 on the site of the Stanhope Arms by Serge Chermeyeff, self-taught architect and designer, the highly innovative building became Gilbey's head office when Gilbey moved from the Pantheon.

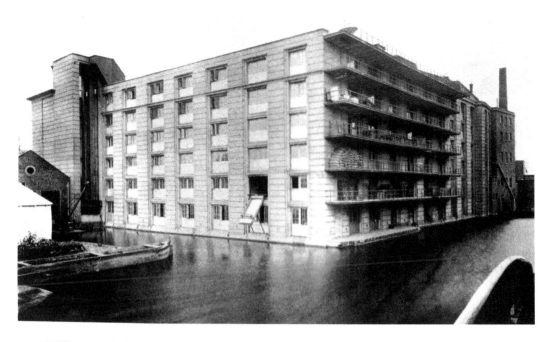

William Hucks' bottle stores

The bottle stores were built in 1896 to rationalise and improve operations of Gilbey's diverse facilities. The distillery and a number of properties on Jamestown Road with stables and wharves, were incorporated into a building with six or seven shallow storeys (*Ann Eastman collection*). William Hucks, manager of the distillery, was responsible for the works. 100 years later, in 1996, the building was converted to a block of flats with a central light well and called Gilbey House.

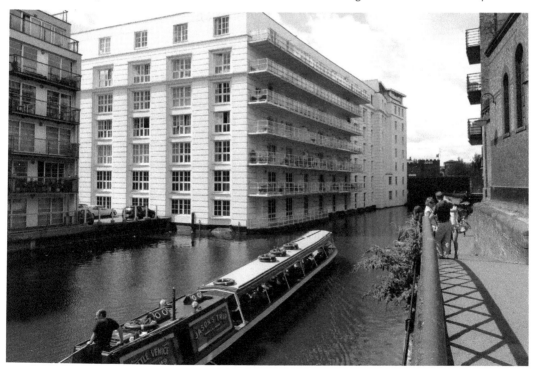

Coal drops

As part of the reconstruction of 1854–6, land up to the Hampstead Road east and west of the Roundhouse was raised to railway level behind a new retaining wall. An access ramp or 'horse road' led from the entrance to Stables Yard to the coal sidings. Further sidings were provided to coal drops (above) supported on vaults, extensions of the 1846 vaults (*Malcolm Tucker*). The Horse Hospital faces these vaults. The vaults were removed in 2008 to the line of the NLR (page 38), and a new building erected with a façade at ground level that mimics the earlier vaults.

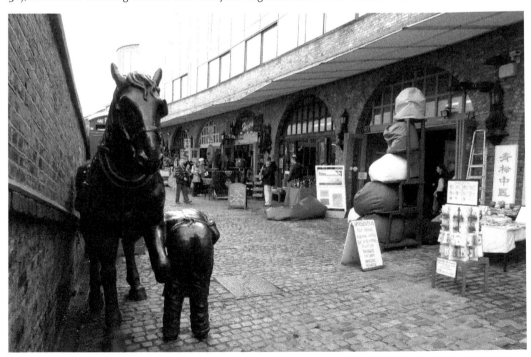

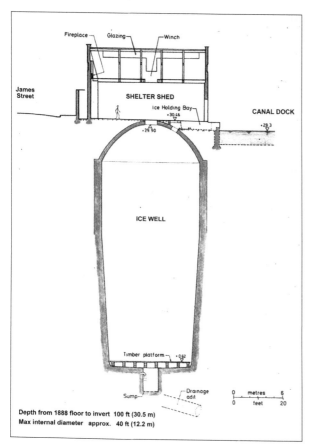

Fireplace — Glazing — Winch

James
Street

SHELTER SHED

Ice Holding Bay

CANAL DOCK

ICE WELL

Timber platform

Sump

Drainage adit

0 metres 5
0 feet 20

Depth from 1888 floor to invert 100 ft (30.5 m)
Max internal diameter approx. 40 ft (12.2 m)

The ice trade

For keeping food and drink cool and making ice cream before mechanical refrigeration, natural ice had to be collected from frozen lakes or canals in winter and stored underground until summer. The source was not always clean.

To meet growing demand, William Leftwich started to import ice from Norway in 1822, bringing it by sea to Limehouse and along the Regent's Canal. This ice well, one of two dug into the London Clay at his wharf and dock at Hampstead Road Locks, dates from 1839. It was deepened around 1846 to 100 feet (30 m) – the deepest ever dug. It could hold over 2,000 tons of ice.

The wharf and the two ice wells are shown in plan on page 5. The arrangements for handling ice are shown left (*Malcolm Tucker*). The melt water drained into a deep well down to the chalk.

The ice well still exists beneath a driveway at 34 Jamestown Road, marked by a circle of bricks in the paving and an information panel on the wall.

55

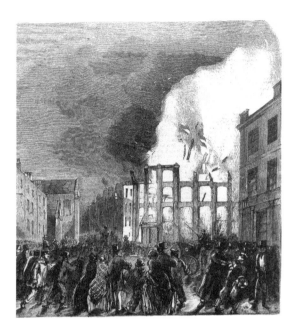

Piano industry

Camden Town enjoyed ready access for transport by canal and rail, close proximity to the skilled furniture makers in the Tottenham Court Road area, and lay within easy reach of West End retailers and a wealthy clientele. These locational advantages helped it to become one centre of the piano industry.

Collard & Collard were the oldest of the well-known piano manufacturing firms of the St Pancras area, having patented an affordable upright 'square' piano in 1811. The piano factory now known as the Rotunda was built for the firm in 1851 opposite its existing works in Oval Road (seen on pages 30–31). An open well in the centre was used to move pianos from floor to floor during the manufacturing process.

In the early hours of 19 December 1851, watchmen from Camden Goods Station spotted a fire in the newly completed factory. The open well, two staircases and eighty-eight windows caused an immense sheet of flames to 'illuminate the whole of London and suburban districts'. Despite drawing extra water from the Regent's Canal, firemen lost control of the flames and the building was gutted. 200 finished instruments were destroyed. The factory was rebuilt and occupied by Collard & Collard until 1929. The building has now been converted to offices.

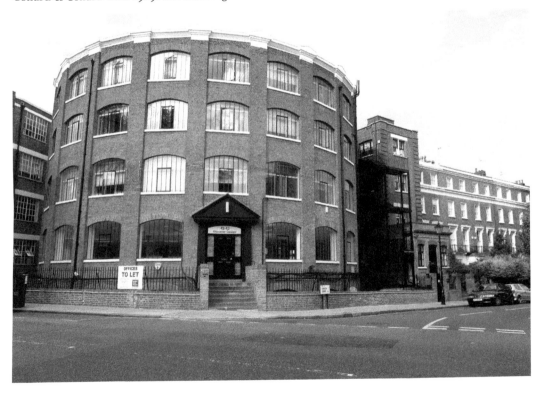

6: The Victorian working horse

London was the terminus of many of the great railway systems built in the Victorian era, and was the largest city in the world with the busiest port. Until at least the First World War, it depended on horses for the transport of goods and people. Victorian London was a 'horse-drawn society', with many thousands of stables.

The provision and care for horses in the early industrial era was poor. Horses were kept at ground level or 'below grade' until about 1870. Stabling of horses on well-aired and lit upper floors accessible by ramps appeared in London from about that date.

The movement of higher value goods both to national destinations and to and from the ports was largely in the hands of the railway companies. Railways were the major users of horses prior to the First World War. While the heavier tasks such as shunting were typically undertaken by Shire horses and Clydesdales, the great majority of horses in railway company stables comprised heavy horses for goods cartage and half-heavies or vanners for faster parcels and passenger luggage duties.

A number of other companies and individuals were involved in this carrying trade. The two largest of the carrier agents, Pickford & Co. and Carter Paterson, had some 4,000 and 2,000 horses respectively. In total the metropolitan carrying trade amounted to some 25,000 horses, about 10 per cent of all the horses and ponies working in London at the end of the nineteenth century.

In spite of the enormous impact that horses had on the Victorian industrial scene, there is relatively little evidence in the form of infrastructure. The stables complex at Camden Goods Station is a notable exception and a more interesting and complete example of Victorian industrial stabling than any other in the country.

As part of the remodelling of the goods yard in 1854–56, four new stable blocks were built for the railway company's horses in the wedge of land formed by the Hampstead Road and the NLR south of the single entrance to Stables Yard. A fifth stable block was added a little further north in 1882–83, and became known as the 'Horse Hospital'. There were also horses stabled in the vaults under the railway arches.

All of the stable blocks, including the Horse Hospital, were later extended or raised by additional storeys. The stable complex therefore illustrates the development of stabling over the second half of the nineteenth century and the improvement in conditions under which horses were kept. Many were original stabled in vaults and basements, such as Pickford's Warehouse. Later stabling was constructed as single story buildings with haylofts, and later still, from the 1880s, with two or more storeys accessed by ramps.

Three stable sites connected with the railway have not survived, including those in the basement of Pickford's warehouse, the LNWR stables in Princess Road and the Allsopp stables on Gloucester Avenue near Fitzroy Road Bridge. These last two stables had access to the goods depot via the Western Horse Tunnel. The complex of horse tunnels is itself unique. They were required on operational and safety grounds and facilitated the movement of horses under railway tracks from stables that lay within and around the goods yard to their place of work. Spurs connected the tunnels with the basements of goods sheds and with vaults used for storage.

The stables capacity in and around Camden Goods Station for rail shunting and goods carriage was some 700–800 at the end of the nineteenth century. The role of the horse continued to be important well into the twentieth century. The LMS, successor to the LNWR, had some 2,000 horses employed in the London area in 1938 and the largest 'stud' in the UK.

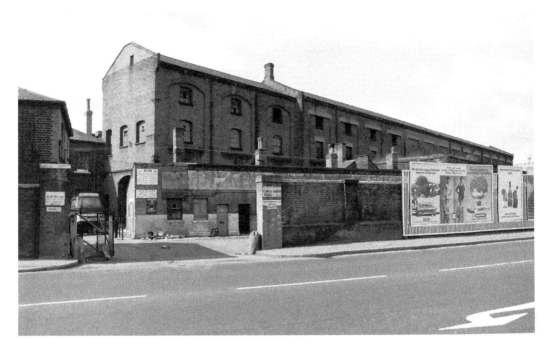

Entrance to Stables Yard

Beyond the entrance to Stables Yard in 1975 the dominating structure was Gilbey's No. 2 Bond, a narrow four storey warehouse. The single storey building facing the entrance was the coal offices. Through the entrance to the right were the coal drops (*Malcolm Tucker)*. The entrance, seen below in 2007, leads to Stables Market and to the five stables ranges which, together with a number of arches, stabled some 420 horses at the end of the nineteenth century. The so-called 'Gin House' remains from Gilbey's No. 2 Bond, demolished in 1985 (*Eric Braun*).

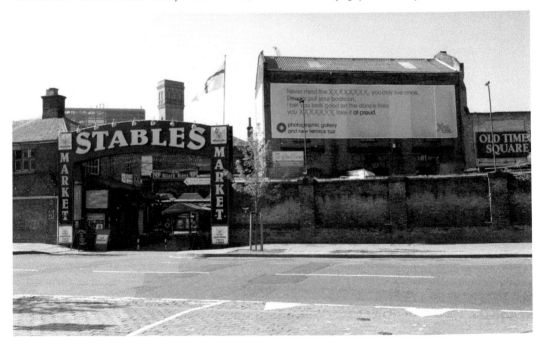

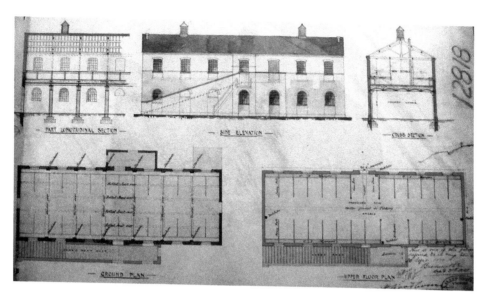

Original plans and elevations

The stables ranges built in 1856, with stables on the ground floor and hay lofts above, were later raised to provide additional stabling. The proposed alterations of 1881 to Long Stable (above) are shown. The Horse Hospital (below) was built in two phases: the western and larger part for ninety-two horses in 1883, the eastern third in 1897. A plan and elevations of the first phase are shown. The ground floor has five bays with cast-iron classically finished columns to central openings, probably intended as cart sheds, but changed to stables under pressure of growing horse numbers (all *National Archives*).

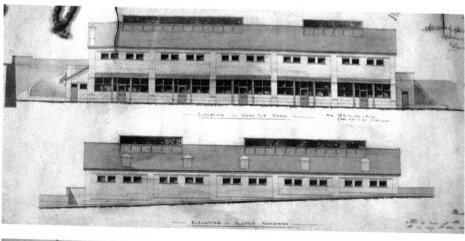

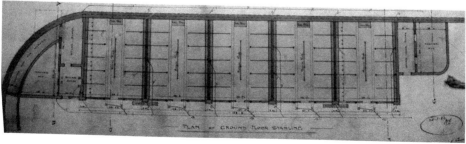

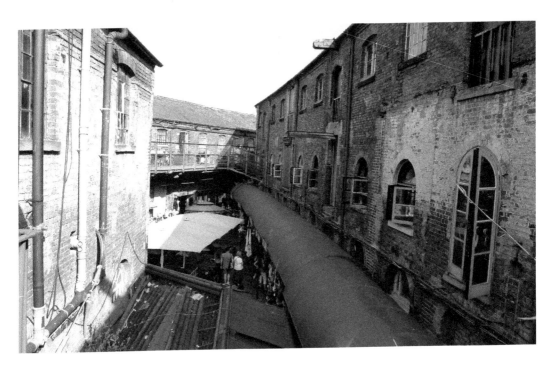

Stables ranges

From the bridge connecting Long Stable to Provender Stores, the view above looks east showing, from the left, Long Stable, The Stables and Provender Stores. This part of the stables complex creates a strong impression of its industrial past. Below the Tack Room, The Stables at end, and Long Stable right. The chimney left served the first floor of the Tack Room where the horse master lived. It is now the offices of Stables Market Limited (*Eric Braun*).

Stables Yard in 1975

Stables ranges are shown in 1975 before their incorporation into Stables Market. Clockwise from above left: Provender Stores showing one of the door openings and hoists to first and second floors where fodder and nutrients were stored and feed was processed by machinery; Provender Stores and Tack Room, with the bridge between them; the western seven bays of The Stables, featuring the original single storey and loft arrangement general to the 1856 stabling; the northern flank of the Horse Hospital with horse road leading up to the coal sidings (all *Malcolm Tucker*).

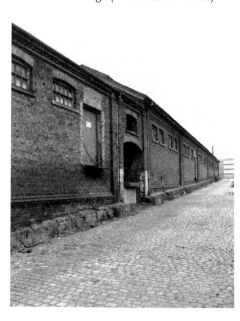
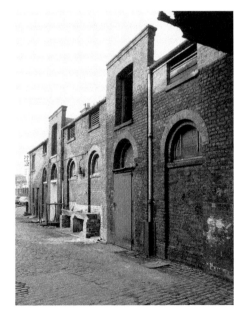

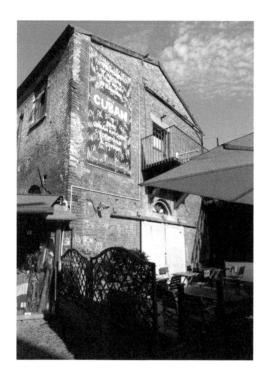

Stables Yard now

The east gable end of Long Stable has a widened ground floor opening leading to one of many outside areas for relaxing with food and drink (*Eric Braun*). Twenty-one bays of The Stables were raised in 1900 to provide an upper storey of stabling accessed via a horse ramp (now with wooden steps) along the north side of Long Stable (below right) and the cantilevered gallery shown (above right). Beyond the Tack Room lies the 'Gin House', the remaining part of Gilbey's No. 2 Bond. Windows enhance the industrial character of the stables complex.

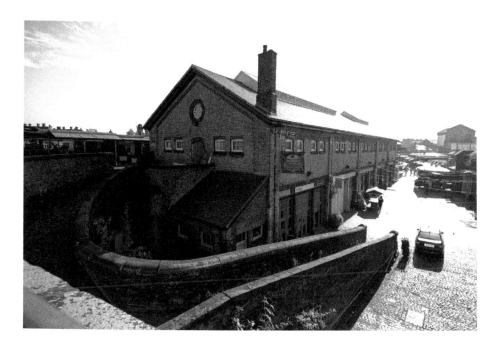

Horse Hospital

At the west end a curved ramp leads to the upper floor of the Horse Hospital, the Grade II* listed jewel in the stables complex (*Eric Braun*). The boiler room, a lean-to feature of the west end, is now offices. The first floor is currently a bar, restaurant, photo gallery and music venue. The first three bays of the upper floor retain twelve loose-boxes with original iron doorposts, grilles, rails and timber boarding as seen below (*Proud Camden*). Some boxes retain drinking troughs and mangers. The ground floor is let to market tenants.

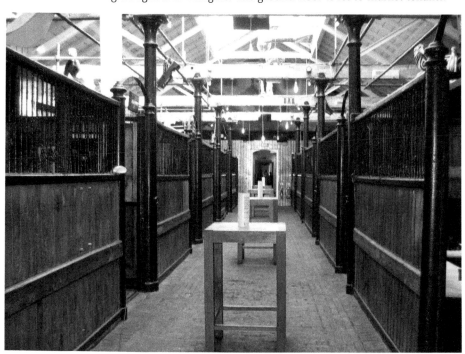

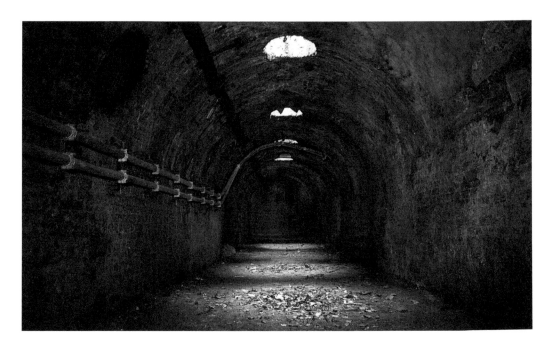

Horse Tunnels

The horse tunnels are unique to Camden, built in 1856 to provide safe passages under rail tracks for horses between their stables and place of work. Part of the Western Horse Tunnel, featured on page 43, has been converted into a restaurant. The Eastern Horse Tunnel runs from Stables Market to emerge via horse stairs (above) at The Henson (*Nik Newman*). Its alignment may be discerned from the cast iron roof vents in the paving of the Interchange forecourt, providing both light and ventilation to the tunnel. Here the tunnel passes under a length of rail track retained from a former goods siding.

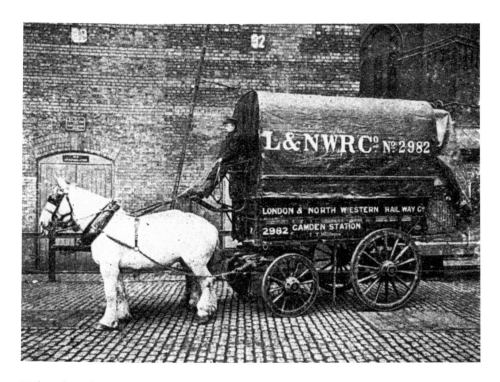

Main roles of working horse

Railways generated vast amounts of work for horses, principally delivery and collection of railway goods but also shunting of wagons. Railway companies required as much space for stables as for engine sheds. The last shunting horse, 'Charlie' a Clydesdale (below), was sold into railway service as a six year old, worked in Camden Goods Station in the 1950s, and was withdrawn from duty at Newmarket in March 1967 at age twenty-four.

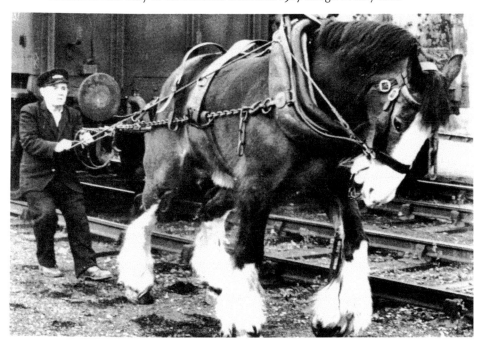

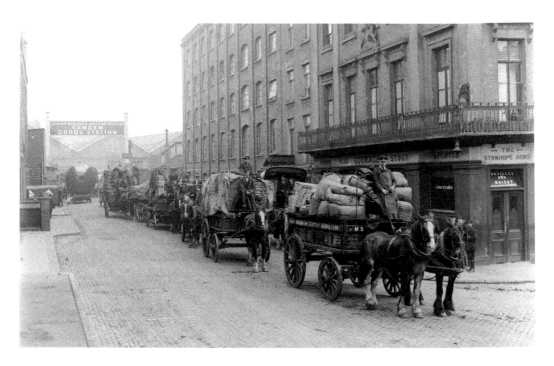

Competition between horses and motor vehicles

Convoys of horse vans and motor vans are seen emerging from Camden Goods Station, Oval Road, alongside the Stanhope Arms, on the same day in about 1930 (*both NRM/SSPL*). The low top speed of the horse was less of a disadvantage in urban areas with traffic congestion. In 1938 motor lorries were restricted to 30 mph (48 km/h), or 20 mph (32 km/h) if articulated or over 2.5 tons loaded. The infrastructure for horses was in place and the cost of maintaining horse-drawn vehicles low. Among railway companies, the LMS was particularly wedded to their use.

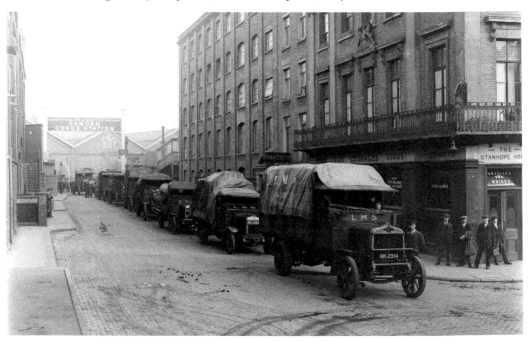

7: The Twentieth Century: LMS and BR

Storage of coaches at Euston soon proved inadequate and new carriage sheds and sidings were opened on the Incline in 1905 with paths for empty trains to run to and from sheds at Willesden. A new tunnel was constructed under Park Street (now Parkway) on the down side. The Up Empty Carriage Tunnel, completed in 1922, was constructed to enable empty trains from the up side to reach it.

Until the twentieth century the LNWR had no suburban services to speak of except those associated with the NLR. After 1907, traffic was lost to Chalk Farm tube station, but the LNWR platforms lingered mainly for ticket collection purposes. Ticket collecting from platforms declined, however, and this, together with the need for space for the new system of sub-surface tracks, led to the demolition of the LNWR Chalk Farm station in 1915. The NLR became part of the LNWR in 1922.

The next stage of major expansion was essentially for suburban services. It was based on the broad concept of an electrified system embracing all the North London lines west of Broad Street, an electrified line to Watford, and the extension of the Hampstead services by electric trains to Kew Bridge. The main lines from Euston to the north were already far too crowded to permit an intense electric service being superimposed on them. The decision was taken to build a 'New Line' on which the suburban electric services, designed for four-rail DC electric trains, would be almost entirely independent of the main lines. At Willesden Junction and eastwards to Chalk Farm widening could be done most conveniently on the up side of the line.

Various stages of the New Line within Camden were completed over 1915–1917, including two single track tube-type tunnels just north of the original Primrose Hill Tunnel. However, the entire project was held up pending the complete track-remodelling scheme at Chalk Farm, which created a highly elaborate system of burrowing junctions to enable electric trains to reach the tunnels from the Euston line or from the North London Line without interfering with other traffic. The up and down fast lines were on the south side, but on the Euston side of the tunnel they divided and down Camden Bank they straddled the slow lines. Work was suspended in 1917 – the part-completed tunnels being used as air raid shelters – and the new layout was not commissioned until 1922.

As the railway grew in size, the intrusion of noise and pollution destroyed the pleasant nature of the area and was responsible for urban and social decay in Primrose Hill and adjacent Camden Town. The smoke reduced the desirability of the houses and many well-known residents (such as Mary Webb, Cecil Sharp and Stanley Spencer in Adelaide Road) found accommodation elsewhere in Hampstead. Houses were rapidly subdivided to provide lodging rooms. The presence of a male work force living in cheap lodging houses away from home resulted in the proliferation of drinking houses and brothels, the latter being documented even in streets now representing some of the most sought after in the area (such as Gloucester Avenue, St Mark's Crescent and Park Village East).

After the opening of Willesden sheds, which housed all the freight locomotives and many of those required for suburban service, Camden Shed or motive power depot (MPD) had only to cope with some fifty to sixty engines, all express types apart from some tanks for pilot work, shunting and ferrying empty carriages. The Shed was used by the largest and newest locomotives, the allocation under LMS and British Rail (BR) tending to consist entirely of Patriots, Jubilees, Royal Scots and Pacifics.

Locomotives discharged smoke and steam continuously as they shunted. Steam engines were fired and cleaned out at Camden MPD behind the wall close to Dumpton Place. In spite of the notices at the Shed warning drivers to avoid the dreaded 'black smoke', the smoke, dust and grit created an enormous and demoralising domestic cleaning effort, as well as a high incidence of respiratory diseases. In the 1930s nearly 600 trains daily ran in and out of Euston. Down trains were estimated to have blown up to a hundredweight (51 kg) of soot from their chimneys before they reached Primrose Hill Tunnel. Large flakes of soot floated and settled everywhere.

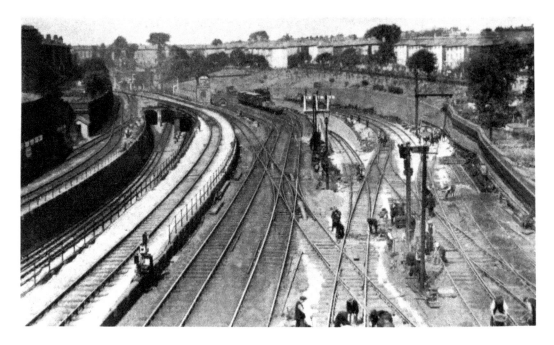

Primrose Hill Tunnel approach cutting

The complex track layout and burrowing junctions, being completed here in 1922, were part of the extensive works involved in the Chalk Farm to Kensal Green track widening for the inauguration of electric suburban services. The flyunders allowed the electrified slow lines to pass under the main lines without conflicting movements. *Below*, Class 87s pass in the Primrose Hill Tunnel approach cutting in 1992. On the left No. 87022 *Cock 'o the North* on the up fast line to Euston and on the right No. 87029 *Earl Marischal* on the down fast line to Manchester (*Brian Morrison*). In the background the former engine drivers' hostel.

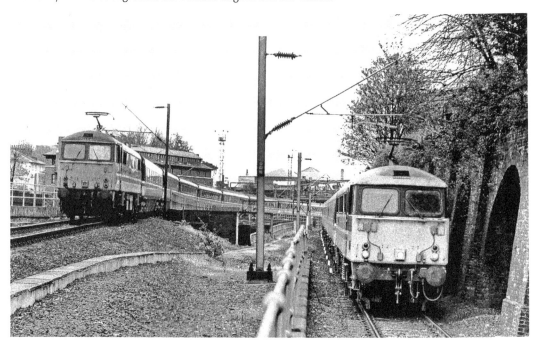

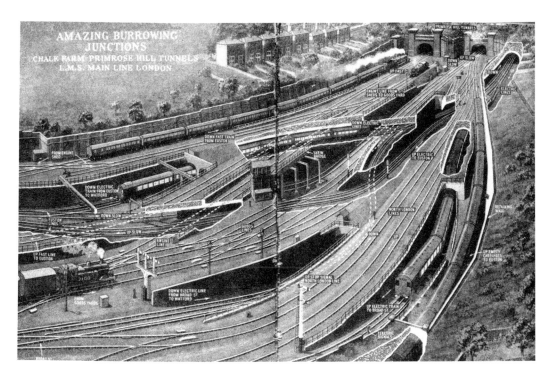

L. Ashwell Wood illustrated the centre pages of *The Eagle*, the seminal British comic paper weekly, where he treated young readers in the 1950s to vibrantly illustrated technical cutaways of modern mechanical wonders. Here he turns to a cutaway diagram of the burrowing junctions. The arrangement is shown in plan below. Underground sections are shown dashed. Twin HS2 tunnels to Euston are planned to cross the area diagonally, with a vent shaft in the woodland on the north side of the cutting. The HS2-HS1 link is proposed to emerge onto the North London Line at a portal close to the former Primrose Hill Station (*Map data: Google, Bluesky*).

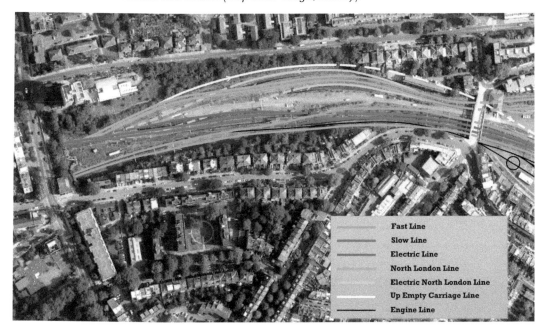

	Fast Line
	Slow Line
	Electric Line
	North London Line
	Electric North London Line
	Up Empty Carriage Line
	Engine Line

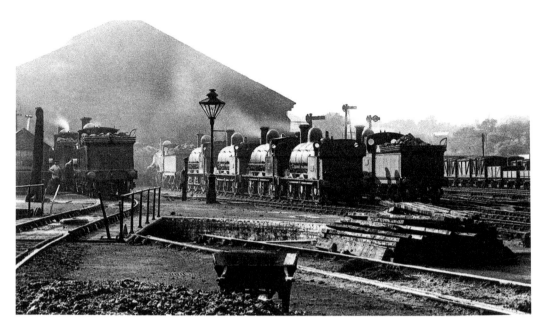

Camden Engine Shed

The southeast end of Camden engine shed or motive power depot (MPD) around 1900 (*Stanley Ellames collection*). MPDs were where locomotives were stored, cleaned, fuelled and given routine maintenance. From 1873, when LNWR opened the locomotive depot at Willesden, the shed was used mainly by large express locomotives, as seen in the evocative oil painting by Peter Green of the northwest of the Shed in 1938. Streamline Pacific No. 6220 *Coronation Scot*, in original blue livery with silver stripes, passes a Stanier 2-6-4 tank hauling an up local train. Patriot class 4-6-0 No. 5512 *Bunsen* is on the turntable.

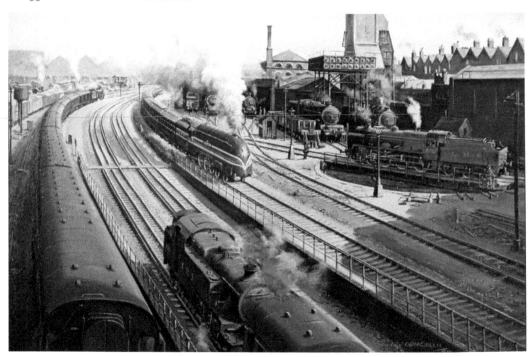

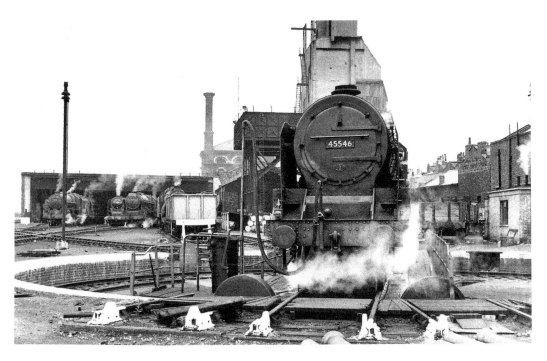

Un-rebuilt Patriot 4-6-0 No. 45546 *Fleetwood* is reversed in 1958, with the shed in the background containing Black Five 4-6-0 No. 44942, Duchess No. 46238 *City of Carlisle*, rebuilt Patriot No. 45528 and Caprotti 5MT 4-6-0 No. 44752 *(Brian Morrison)*. Below, the shed from the southeast in *c.* 1937, the two tracks of the 'back road' leading past the ash pits and ash handling plant, and under the entrance footbridge from Dumpton Place to the coaling plant, two bunkers of 150 tons each, and to the water tank seen above.

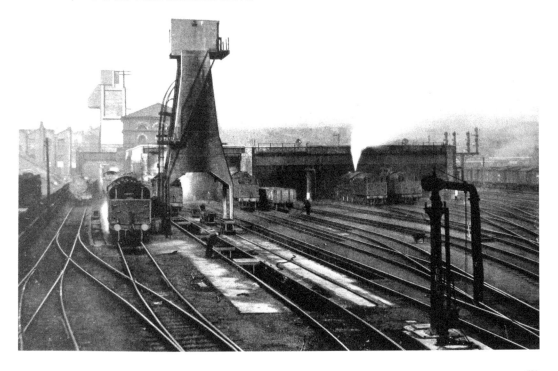

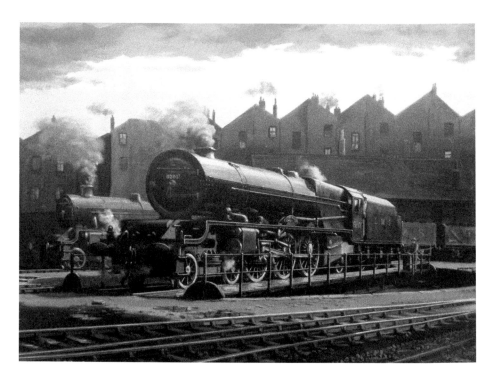

On the turntable

Princess Royal class No. 6201 *Princess Elizabeth*, built in 1933, on the 70-foot (21 m) Cowans & Sheldon vacuum operated turntable, installed in the mid-1930s *(G. Peter M. Green)*. On 3 June 2012, on Battersea Railway Bridge, it sounded its whistle to signal the start of the Thames Diamond Jubilee pageant. It is now based at Crewe Heritage Centre. Below Jubilee No. 45660 *Rooke* is reversed in March 1962 (*R. C. Riley*). The Shed came to a standstill on one occasion when a driver overshot the turntable and buried the locomotive's tender in the cellar of the Pembroke Castle, much to the concern of the publican.

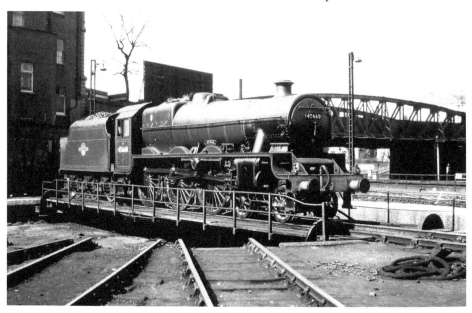

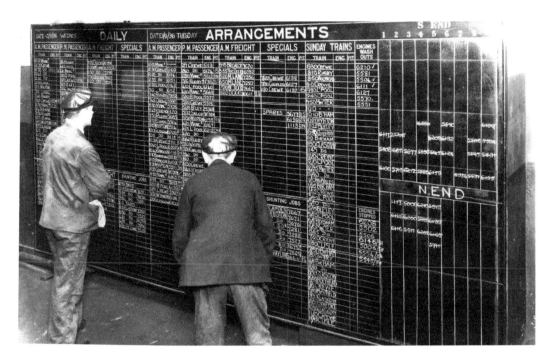

Locomotives and enginemen

The Daily Arrangements Board on 1 September 1936 illustrates the task of scheduling locomotives through the Shed (*H. C. Casserley collection*). A relic of Camden Shed is the enginemen's hostel, overlooking the line just west of Regent's Park Road Bridge. Originally called Stephenson House when built in 1928, and almost destroyed by fire, Iron Bridge House now serves as offices for media companies.

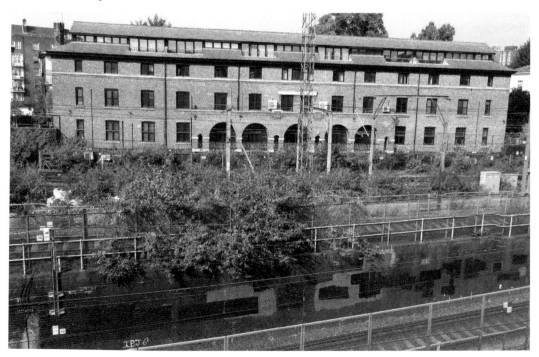

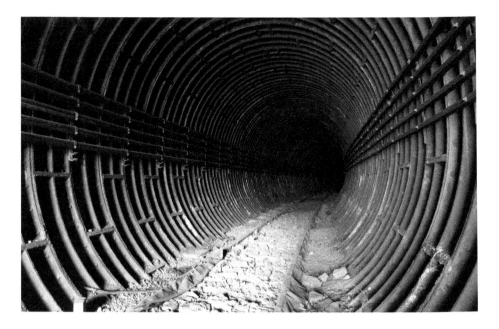

Up empty carriage tunnel

The 'Rat Hole' as it was known to train drivers served to ferry empty carriages from Willesden to Euston. It dates from the early twentieth century. Although it now carries EHV cable, it was never electrified. Train crews went to great lengths to avoid stalling in its fume-laden close confines. It runs from just east of Primrose Hill Tunnel crossing under the mainline and former winding vaults to emerge north of Parkway. Limited clearance restricted the tunnel to empty coaching stock as carriage doors would not open in an emergency. An 80-foot (24 m) shaft located in the Western Horse Tunnel provides access (*both Elliot Sinclair*).

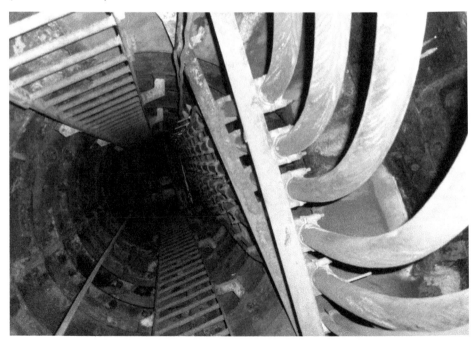

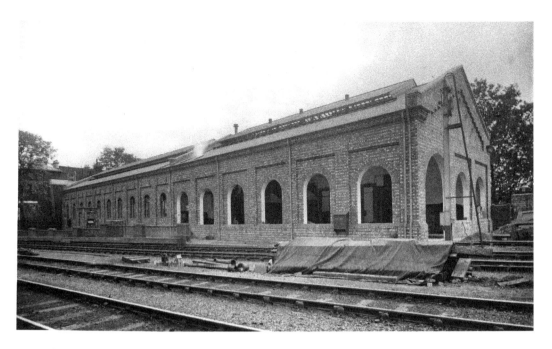

Electricity sub-station

The sub-station nears completion in July 1906, seen from the northern side. It was to supply power to the new electrified lines via EHV cables routed through the Western Horse Tunnel, down the shaft shown opposite and into the Up Empty Carriage Tunnel. The southern part of the substation later served for a time as a diesel oil store. It has now been converted to flats at 36 Gloucester Avenue, as seen from the south side. The northern part provides DC for the third running lines and 11 kV AC supply to overhead lines.

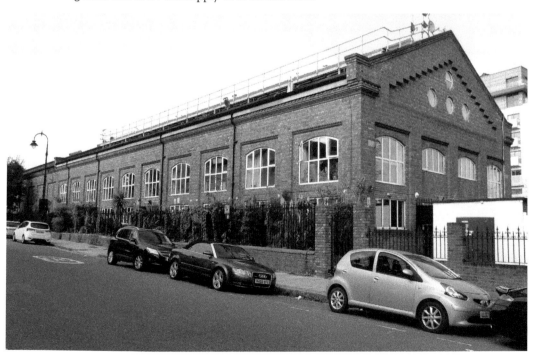

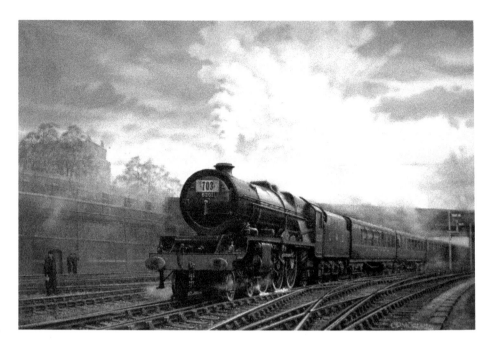

On Camden Bank

The Princess Royal Pacific No. 6201 *Princess Elizabeth* begins the climb of Camden Bank at the start of its epic 401.5-mile (646 km) non-stop run from London to Glasgow in 5 hours 53 minutes 38 seconds on 16 November 1936. The following day, it made the return run in 5 hours 44 minutes 15 seconds. Peter Green's oil painting was produced to coincide with the diamond jubilee of No. 6201's construction in November 1933. Below, Princess Coronation 8P Pacific No. 46250 *City of Lichfield* and Black Five 4-6-0 No. 44771 both slog up Camden Bank on 7 November 1958, hauling the 'Red Rose' express for Liverpool and empty coaching stock for Willesden respectively (*Brian Morrison*).

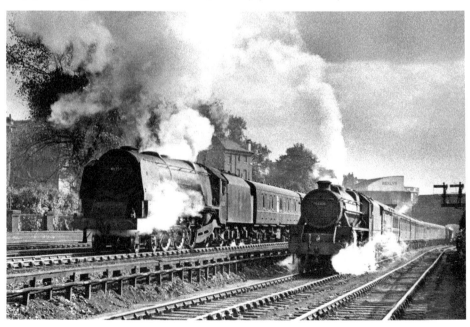

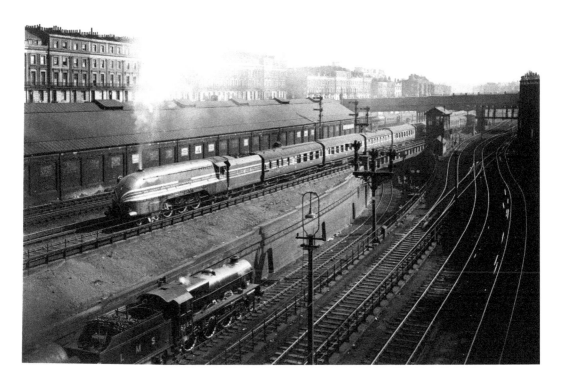

The down Coronation Scot behind blue streamlined Coronation 4-6-2 No. 6221 *Queen Elizabeth* passing the up side carriage shed in 1938. Jubilee 4-6-0 No. 5563 *Australia* is backing out of Euston on the down empty carriage line *(NRM/SSPL)*. Below, a Virgin Class 390 Pendolino from the WCML fleet approaching Parkway Bridge. The dividing wall is a remnant of the elegant curved and battered retaining walls of 1837 (*Mike Dowd*). Camden Bank was widened over 1898–1904 to reduce congestion of trains and allow empty movements in and out of Euston on separate tracks.

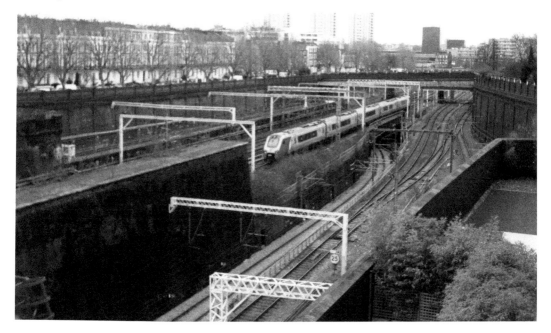

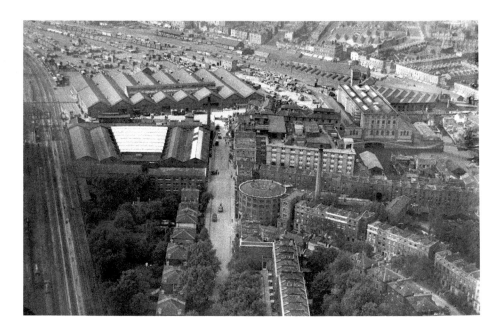

Aerial views of Goods Station

The oblique view from 1921 above looks north along Oval Road to the goods sidings in the distance. The main goods shed is still in its original 1864 form. The Stanhope Arms is seen on Oval Road, but was replaced by Gilbey House in 1937. The entire piano factory complex can also be seen. The plan view from 1948 shows the enlarged 1931 goods shed with travelling crane on the east side. The Great Wall of Camden along Chalk Farm Road is intact (both *English Heritage*).

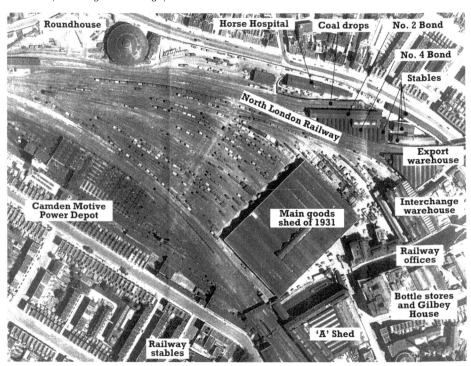

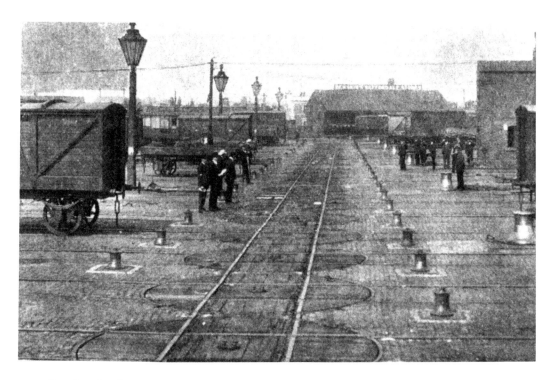

Camden Goods Station in 1930s

Railway staff lined up for inspection at the Middle Cross creating a quiet moment in a busy sea of railway sidings in the 1930s. The warehouse beyond the sidings was for Benkins Watford Ales & Stouts, located above the present site of the Morrisons petrol station. Shunting at this time was performed equally by locomotives and by hydraulic capstans and turntables as shown below where goods trains are being assembled in front of the main goods shed. The thirty-seven sidings could hold about 1,100 wagons.

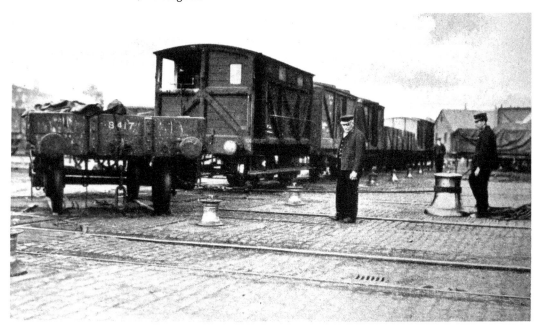

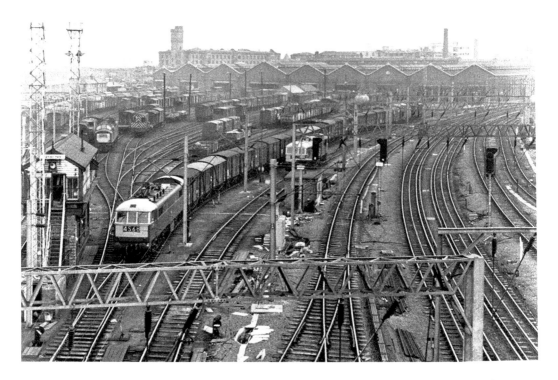

The scene in front of the main goods shed *c.* 1965, with Classes 40, 08 and 86 diesel locomotives, has a tired atmosphere, anticipating its further decline (*53A Models of Hull collection*). Today the picture is very different, housing, markets, supermarket and petrol station taking up much of the former Goods Station. The Roundhouse and Interchange remain familiar landmarks, and other historical features have been adapted for commercial use (*Map data: Google, Bluesky*).

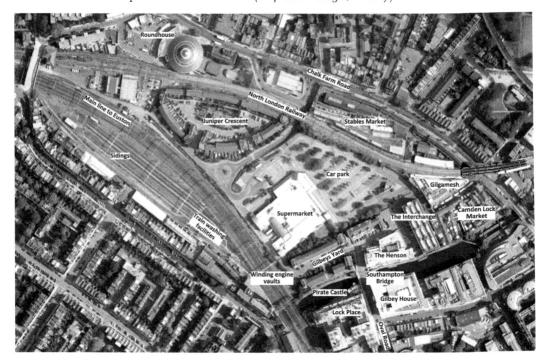

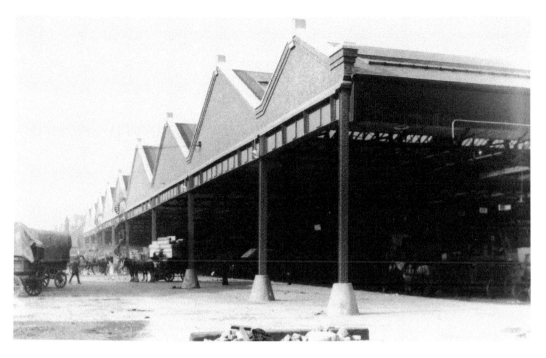

The goods shed

The LNWR goods shed, built in 1864 to replace several smaller scattered goods facilities, had a plan area of 100,000 sq. ft (9,289 sq. m), and was the largest at that time in the country. It could hold 135 wagons. About 750 wagons, containing some 1,500 tons of goods could be loaded and despatched a night. Underneath were vaults, extending over the whole area of the shed and connected by a spur to the Eastern Horse Tunnel (below left) for the storing of Allsopp's Burton ale *(both Nick Catford)*. The shed was enlarged in 1931 and these images are of the enlarged LMS shed. The goods shed was demolished in the 1980s.

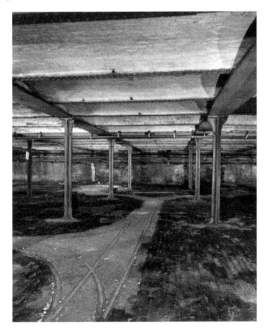

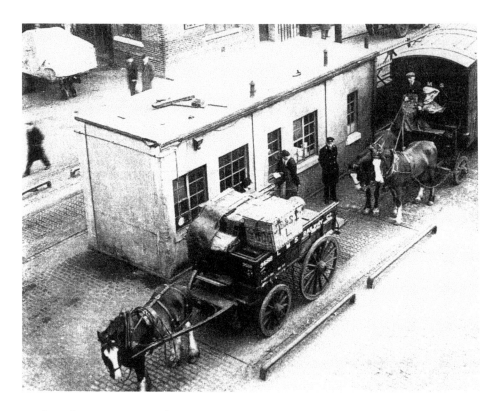

Oval Road entrance to Goods Station

Goods vans entering or leaving the Goods Station through the Oval Road entrance were weighed at the weighbridge, dating from 1931. The frame of the weighbridge, made by Pooley of Birmingham, is seen today in the granite setts in front of The Henson, the building on the site of the former railway offices that incorporates the original façade on several sides. The Henson takes its name from Jim Henson's Creature Shop, of Muppet fame, which occupied the building in the 1990s.

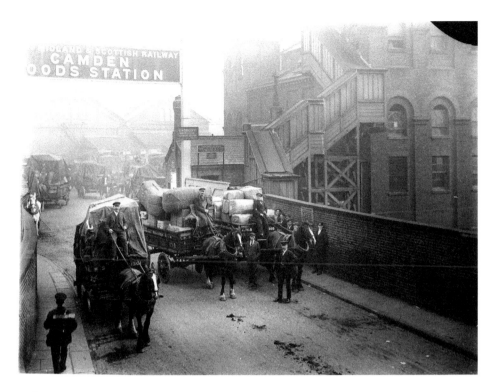

Railway offices

Horse drawn goods traffic in around 1930 emerging from the Camden Goods Station entrance on Oval Road alongside the offices of LMS and their agents at 30 Oval Road (*NRM/SSPL*). The stairs led to the first floor where clerical staff had their desks. The main goods shed is seen in the background. A later extension of the offices in the 1960s, as part of a British Rail facelift, aligned part of the façade with the 'LMS' entrance as shown below. The staircase then ran up the canal frontage to the first floor. The entrance is now an archaeological curiosity.

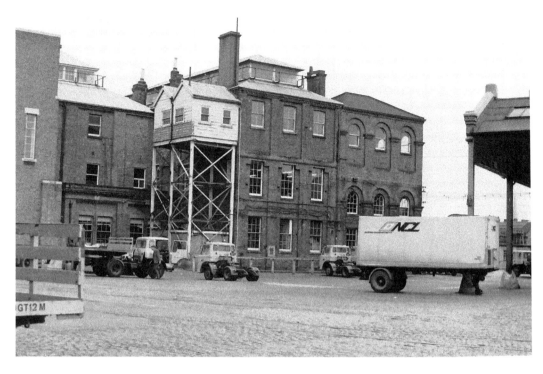

The railway offices above, built in various stages from 1856, were for both railway and goods carrier staff (*David G. Thomas*). Van drivers entering through the Oval Road entrance would communicate with clerical staff on the floors above via the speaking tubes shown below left, and would be directed to where they were to unload. Below right a tranquil scene looking east from Southampton Bridge with narrowboats on moorings and a punt flying the Jolly Roger.

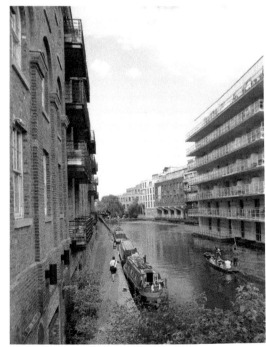

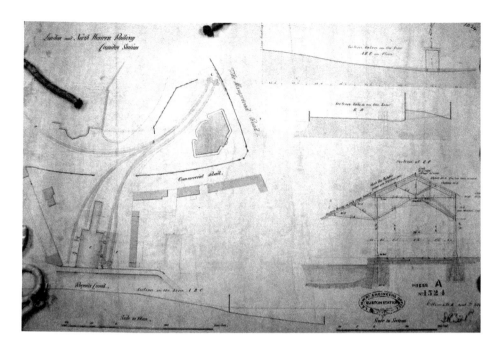

Interchange Warehouse

The LNWR created its first interchange depot in 1848, using a reversing spur from goods sidings to descend from railway level to its own dock (*National Archives*). Evidence of the reversing spur remains in a skewed arch under the NLR (shown in plan on page 91). It was rebuilt and enlarged more than once in the nineteenth century, reaching the form shown on page 48 in the last decade. The 'New Warehouse' seen today dates from *c.* 1905 and represents a singularly sophisticated example of storage and three-way transfer. It is currently leased by Associated Press Television News from the Canal and River Trust.

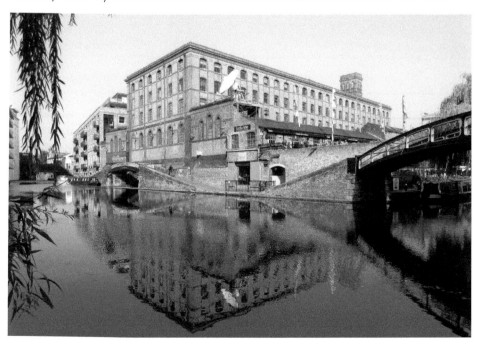

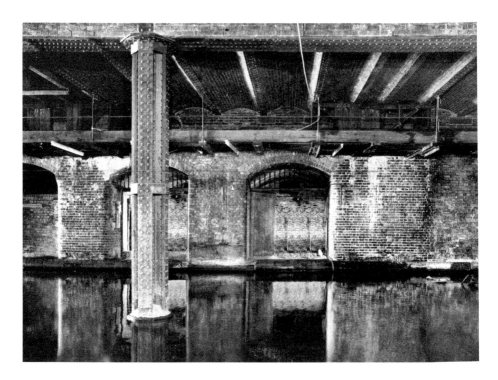

Canal transhipment

A line of massive octagonal riveted columns runs down the centre of the canal basin, locally known as 'Dead Dog Hole', which the Interchange building straddles (*Nick Catford*). The dock could accommodate six barges or twelve narrowboats. The image below shows the trap doors for moving goods to/from storage above and a cantilevered platform providing access to crane slewing gear (*Eric Braun*). The openings seen above are to the beer vaults (page 49) built for Allsopp in 1856 that provided direct access to the dock. These were bricked up when Gilbey took them over for wine vaults.

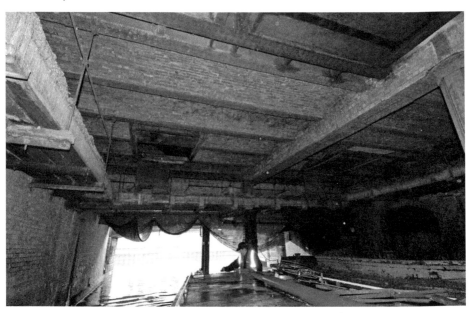

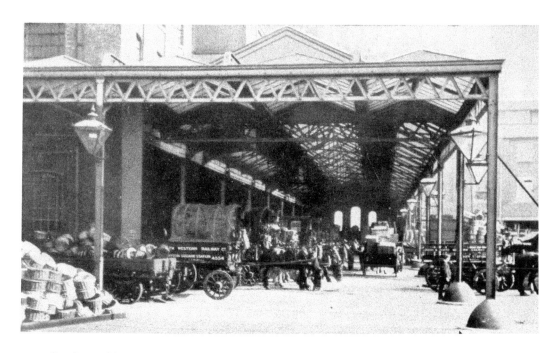

Road transhipment

The ground floor of the Interchange was open on both the west side and partially on the north, where horse drawn vans are being loaded in around 1910 under glazed canopies, now removed *(F. E. Bell)*. Transhipment was mainly between rail and road via a raised loading platform running through the building. Internal cranes and hoists allowed goods transfer between the storage levels and ground level. Doors to the storage areas are clearly seen on todays west façade. External hoists were provided here under hoods, since removed.

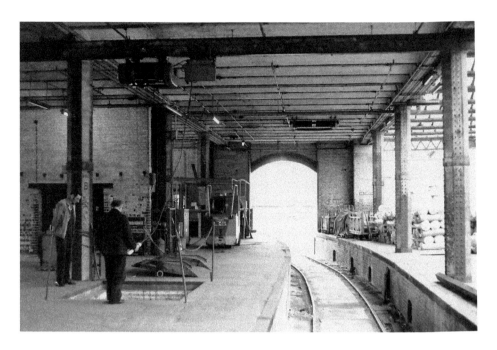

Rail transhipment

The loading platform allowed goods transfer between road and rail (*David G. Thomas*). The large hatch in the platform was for goods transfer by crane to/from the basement warehouse. The trapdoor, above, was for transfer between storage and rail wagons. The platform right was for inter-rail transfer. The loading platform is seen from the basement below *(both Malcolm Tucker)*, raised on sleeper walls and ventilated both from canal basin, left, and transit shed, right. The basement warehouse occupies an area of 1,467 sq. yards (1,226 sq. m). Let to Gilbey, it has been empty since the company's departure in 1964.

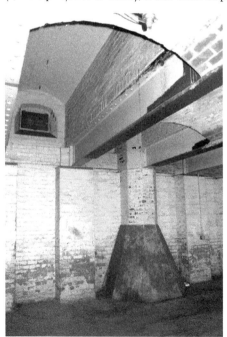

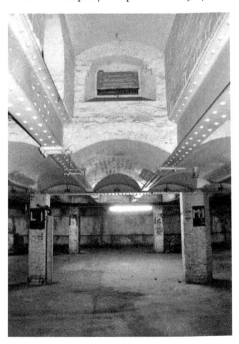

8: Regeneration

The big changes that brought the middle classes back to the area were the Clean Air Act in 1956 and the electrification of the railway. Partly in response to the concentrated clamour of local residents, supported by St Pancras (succeeded in April 1965 by Camden) Council, British Rail introduced diesel main line locomotives as an interim measure. But it was only when the full electrification programme had been completed that the air became clean, the greatest change to the area since the original developments of the nineteenth century.

The slow lines for outer suburban services, together with the fast lines, were electrified in 1966. Bridges and other structures were altered to clear the way for overhead electric wires. Individual small signal boxes were removed and replaced by large power-operated boxes sited at strategic points along the line to control the new colour-light signalling system. The next major upgrade was undertaken by Railtrack between Euston Station and the Primrose Hill Tunnels over 1998–2000, and included track renewal work, signalling and overhead electrification.

The last horse-drawn traffic on the Regent's Canal was carried in 1956 and by the late 1960s commercial traffic had all but vanished. The regenerated towpath was opened on 20 May 1972. It was followed later that summer by the opening of the crafts market at what was branded 'Camden Lock' in the former Dingwall's timber yards. The original market has expanded and been joined by Stables Market, Canal Street Market, and Buck Street Market to form, together with Inverness Street Market, the largest and most popular street market in the UK.

The Pirate Club was founded by Viscount St David's in 1966 to provide water-based activities for the young but, after a number of acts of vandalism, needed more secure and permanent premises. The Pirate Castle, designed by Seiferts, opened in 1977. Despite a chequered funding history, it is now flourishing after building an extension in 2007–8 that provided better facilities and conference space that can be hired.

The former Camden Goods Station has also been transformed. The Goods Depot closed c. 1980 and British Rail sold most of the site in the 1980s. Much of the area was developed for social housing, with Juniper Crescent in the north and Gilbeys Yard in the south. The centre was taken by Safeways (now Morrisons), Camden's first supermarket.

At street level in Stables Yard the sale of land and buildings in 1995 led to the formation of Stables Market, since when it has undergone a series of transformations. The Gilgamesh complex opened in 2005 providing market stalls at ground level alongside the viaduct of the NLR. Horse Tunnel Market in 2006 expanded the retail area into former vaults and started the prominence of the horse theme that now dominates the market. In 2009 the 1846 vaults and arches under the NLR were redeveloped. A year later a new basement floor for additional retail and other facilities was created together with a new four storey building that runs along the north side of the NLR.

The Roundhouse was relaunched in 1966 and soon became an iconic rock venue, hosting Jimi Hendrix, Led Zeppelin, Pink Floyd, Cream, the Rolling Stones, The Who, Elton John, David Bowie and many others. It also acquired a growing reputation for cutting-edge theatre which gradually displaced rock as noise and licensing restrictions took their toll. It closed in 1983 and had a chequered history for the next twenty years until the 2004–6 regeneration.

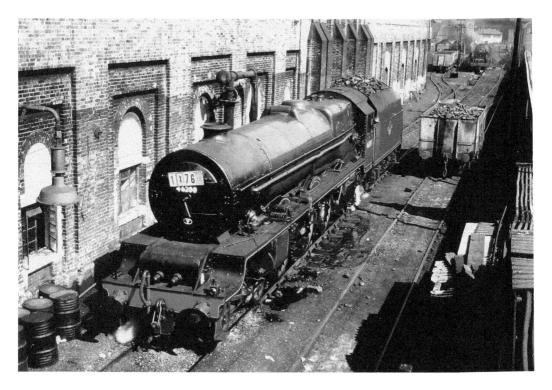

Last days of steam

No. 46200 *The Princess Royal*, first of the 'Princesses', started its working life in Camden in 1933. Here, on 3 June 1962, in its last year of operation, it stands resplendent next to the Shed having been coaled (*R. C. Riley*). After the banishment of steam in 1962, Camden Shed enjoyed a brief twilight, housing diesels. The Shed was closed completely in January 1966 and pulled down the same year to be replaced by smokeless sidings and train washing facilities.

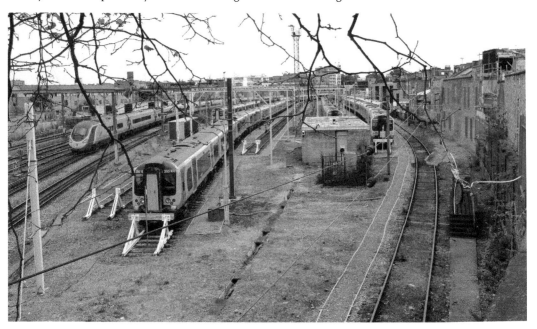

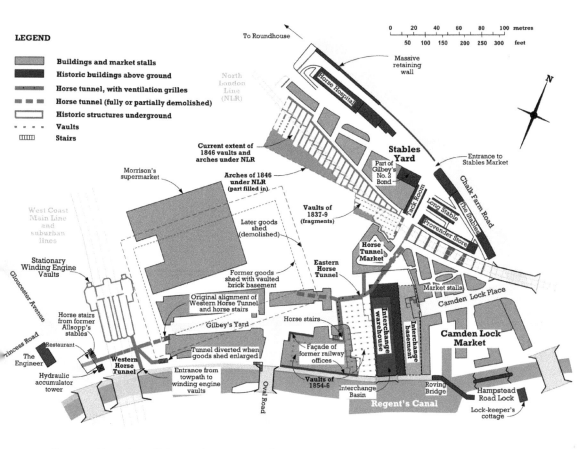

LEGEND

- Buildings and market stalls
- Historic buildings above ground
- Horse tunnel, with ventilation grilles
- Horse tunnel (fully or partially demolished)
- Historic structures underground
- Vaults
- Stairs

To Roundhouse

Massive retaining wall

North London Line (NLR)

Current extent of 1846 vaults and arches under NLR

Morrison's supermarket

Arches of 1846 under NLR (part filled in)

Later goods shed (demolished)

Vaults of 1837-9 (fragments)

Stables Yard

Part of Gilbey's No. 2 Bond

Entrance to Stables Market

Tack Room

Long Stable

The Stables

Chalk Farm Road

Provender Store

West Coast Main Line and suburban lines

Stationary Winding Engine Vaults

Former goods shed with vaulted brick basement

Eastern Horse Tunnel

Horse Tunnel Market

Gloucester Avenue

Horse stairs from former Allsopp's stables

Original alignment of Western Horse Tunnel and horse stairs

Gilbey's Yard

Horse stairs

Market stalls

Camden Lock Place

Interchange warehouse

Interchange basement

Camden Lock Market

Princess Road

Restaurant

The Engineer

Hydraulic accumulator tower

Western Horse Tunnel

Tunnel diverted when goods shed enlarged

Entrance from towpath to winding engine vaults

Façade of former railway offices

Oval Road

Vaults of 1854-6

Interchange Basin

Roving Bridge

Hampstead Road Lock

Lock-keeper's cottage

Regent's Canal

Preservation, demolition and reconstruction

Historical features that remain are shown in various shades of brown and newer buildings in grey in the schematic plan of the southeast corner of the former goods station. The development of the former railway offices, now The Henson, symbolises one form of regeneration: parts of the façade are retained while less obvious features – the 1856 vaults that formed the basement (see below) and the access to the horse tunnel – are all but lost. This was the scene in June 2008 (*Eric Braun*).

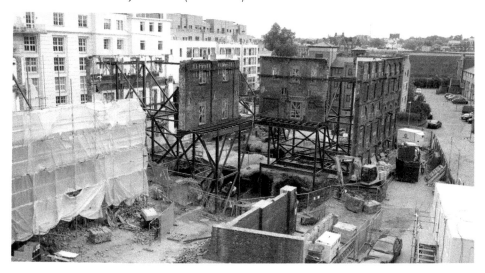

91

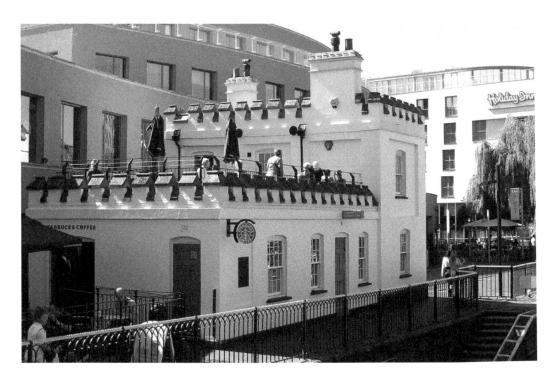

Camden Lock

The regeneration of the towpath led to the restoration and upgrade of the Lock Keeper's Cottage, dating from 1816, as the Regent's Canal Information Centre, a role it combines with being a coffee house. In the early 1970s a property company bought the yard at Hampstead Road Locks and converted it to workshops let to crafts people, branding it as 'Camden Lock'. The creative energy released was translated at weekends into an exciting retail market that grew and spread up the high street into clothes, music, food and entertainment. The five Camden markets are now among the top tourist destinations in London. Below, West Yard on a quiet morning.

Roundhouse regeneration

A new exoskeleton of steel rafters and beams, and reconfigured cone, is seen above in August 2005 during the conversion works (*Celia Kelly*). Some of the acoustic panels are in position and concreting for the new building is almost complete. The Roundhouse reopened in 2006 after a £30 million metamorphosis, and is now a vibrant performance centre at the heart of Camden's music scene. In summer beach huts, sun umbrellas and 150 tons of sand are imported to create Camden Beach.

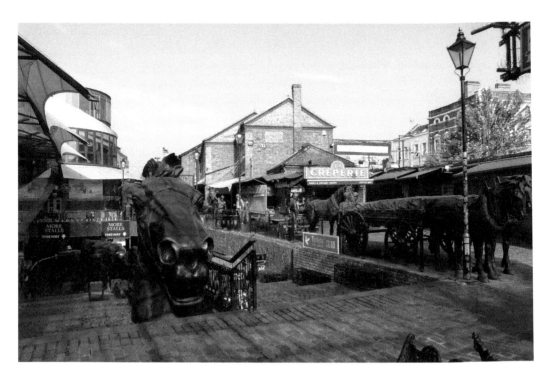

Stables Market

Stables Market has been under continuous development and new glass and steel buildings are now juxtaposed with older stables and vaults of Stables Yard. Here, at its centre, steps descend to a new basement level. The Horse Hospital is in the middle distance. Horse Tunnel Market has been created at the Stables Market end of the Eastern Horse Tunnel, seen below, with cross-passages from one market area to another. The horse features as a theme throughout the market.

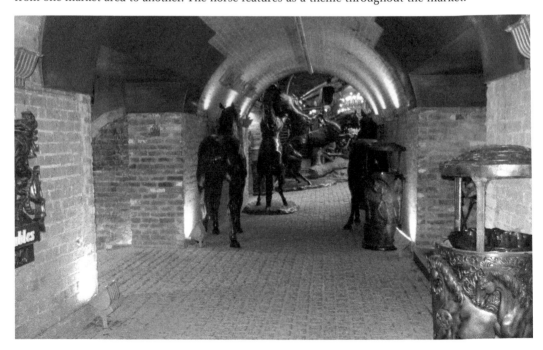

Stables

Two historic spaces being put to typical commercial use: above, the first floor of Provender Stores occupied by Zen-do, a kickboxing centre; below, the ground floor of Long Stable is home to the Cuban Bar. The upper floor is supported on brick jack arches spanning between rolled joists carried by wrought-iron I-section girders that bear on cast-iron stanchions, a structure that is clearly revealed. Both stable uses seem to adapt naturally to these remarkable spaces.

Rear cover images:
Central vault, stationary winding engine vaults, April 2008
(*Dan Cruickshank*).
Performance Space, The Roundhouse, 2006
(*Hufton and Crow*).

Lamp standards *c.* 1900 on Mornington Bridge overlooking
Camden Incline

Further reading

In Camden Town, David Thomson, Penguin, 1983.

The Euston Arch and the Growth of the London, Midland and Scottish Railway, Alison and Peter Smithson, Thames and Hudson, 1968.

Camden Railway Heritage Trail, Primrose Hill to Camden Lock and Chalk Farm, Camden Railway Heritage Trust, 2009.

The Regent's Canal, London's Hidden Waterway, Alan Faulkner, Waterways World Ltd, 2005.

The Growth of Camden Town: AD 1800-2000, Jack Whitehead, privately published, 2nd Edition, 2000.

Camden Railway Heritage Trust

Camden Railway Heritage Trust (CRHT) is a charity promoting, for public benefit, the preservation and restoration of the railway and associated heritage, access to the heritage and the education of the public in the broad appreciation of the social and industrial history of the area (**www.crht1837.org**).

Acknowledgements

I would like to thank John Christopher of Amberley Publishing for inviting me to write this book. For permission to reproduce their images I am most grateful to: The Institution of Civil Engineers (ICE); National Railway Museum/Science and Society Picture Library (NRM/SSPL); Yale Center for British Art (YCBA); English Heritage; Camden Local Studies and Archives Centre (CLSAC); Westminster City Archive; National Archives; Diageo Archive; The British Museum; London Canal Museum; Northside Archives; Boiset Waters Cohen Partnership (BWCP); The Roundhouse; Network Rail (NR); Hufton and Crow; Stuart Leech; and Proud Camden.

Many individuals have been generous both with their time and with their photographs, and this book has been greatly enhanced by their contributions. I am particularly grateful to Malcolm Tucker, Eric Braun, David Thomas, Nick Catford, Celia Kelly, Elliott Sinclair, Nik Newman, Harry Jack, Michael Bailey, Roger Cline, Nelson Twells, John Turner (53A Models), Brian Morrison, Rodney Lissenden, Brian Stephenson, Peter Groom, Stanley Ellames, Mike Dowd, Ann Eastman, and Dan Cruikshank.

My special thanks to Peter Green and family for three paintings so evocative of a bygone era.

Every care has been taken to trace copyright holders. Any I have been unable to reach are invited to contact the publishers so that a full acknowledgement may be given in subsequent editions.